THEN & NOW®

SEATTLE

SEATTLE

Clark Humphrey

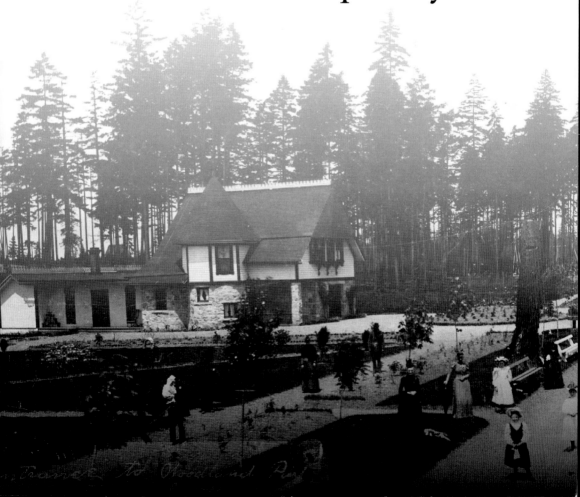

This book is dedicated to the memory of Walt Crowley and Patrick McRoberts, cofounders of historylink.org and dedicated keepers of the Seattle area's oral, written, and visual lore

ON THE FRONT COVER: When the Pike Place Market opened in 1907, its farmer-merchants sold their produce in the open air. Ambitious landlords soon provided covered amenities for merchants and shoppers. These included the two-block-long North Arcade. Rebuilt during a 1970s preservation project, it now hosts artists and craft booths along with the Pure Food Fish Market. (Washington State Digital Archive.)

ON THE BACK COVER: Broadway, the Capitol Hill neighborhood's main retail street, has always been a place of change. Furniture stores and dive bars have given way to fashion boutiques and trendy gay bars. Broadway is shown here heading north from Thomas Street in 1934. The building on the right is now Julia's Restaurant. (Seattle Municipal Archive, no. 8760.)

CONTENTS

ACKNOWLEDGMENTS

Julie D. Pheasant-Albright got me into these photographic history books back in 2006 and provided advice for this one.

This book was supervised at Arcadia by Donna Libert and Tiffany Frary. Special thanks are in order to Seattle Municipal Archives (particularly Anne Frantilla), the Washington State Digital Archive, and the beautiful blog vintageseattle.org (run by the fabulous Jess Cliffe). Historylink.org's articles and archives helped immensely in researching the texts.

Other vital research sources include the University of Washington Libraries, the Museum of History and Industry, the King County Archive, and the Seattle Public Library.

The following abbreviations refer to picture sources used in this book: Seattle Municipal Archives (SMA), Washington State Digital Archive (WSDA), and vintageseattle.org (VS).

INTRODUCTION

Seattle is one of America's youngest big cities, but it has also had its full share of change, renewal, and loss in the past 160 years. The original residents were pushed out, mostly by treaty instead of violent conquest; after that, they were then remembered in place names, statues, and monuments. Early frontier buildings were removed, replaced, or burned. The more permanent structures that replaced them were themselves often replaced. Handsome downtown office buildings were removed for smaller, taller towers with more corner spaces to rent. Mills, factories, warehouses, and other industrial spaces have been expanded, shrunk, or remade into stores, offices, and residential lofts. The city's economic base moved from timber to airplanes and again to software and high tech. In the neighborhoods beyond downtown, modest middle-class homes were renovated with fancy new fixtures or replaced by "McMansions" or rows of townhomes. Whole districts have gone from upscale to downscale and back again. Big ballparks have come up and down. Parklands have been developed with indoor recreational halls, then scaled down for more passive outdoor leisure. This book exhibits a select few dozen of these changed places juxtaposed with the results of those changes.

Some of the sites in this book have been completely rebuilt two or more times. It was hard in these cases to choose one specific then image. In a few places, like Pioneer Square, the same spot has two different stories.

In many cases, it has been impractical or impossible to shoot modern images on the exact same spots as the then images. In some of these cases, trees and shrubbery now obscure former viewing angles of old buildings. Many of this book's now images were taken in late winter and early spring 2011, when the sun was (sometimes) out, but the non-evergreen trees had not yet blossomed.

Like any book on this topic, it is necessarily, wildly incomplete. There's just too much in the city's past and present to fit into one slim volume. Paul Dorpat has explored local historical sites for the *Seattle Times* and other outlets for three decades, and even he hasn't run out of material. If you're curious about a specific place that is not in this book, it might be in one of his.

For still more Jet City legends and lore, look into the works of J. Kingston Pierce, Murray and Lane Morgan, James Madison Collins, Ann Wendell, Bill Speidel, Roger Sale, Emmett Watson, etc. And if that doesn't sate you, you could even pick up my own two previous Arcadia Publishing volumes, *Vanishing Seattle* and *Seattle's Belltown*.

CHAPTER 1

THE PIONEER DAYS

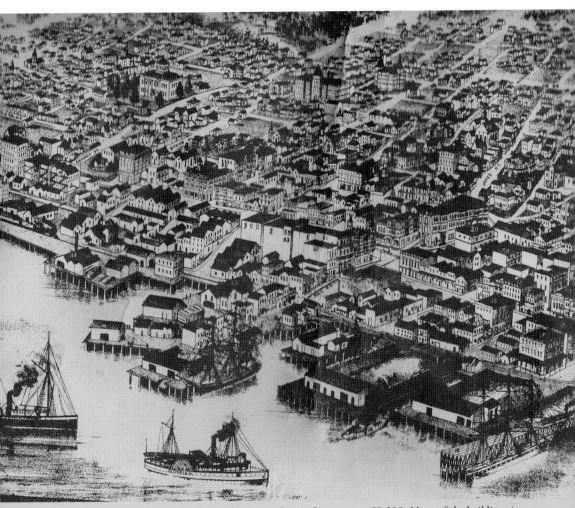

The Llewellyn Dodge & Co. real estate firm created this bird's eye-view map in early 1889, to promote Seattle as a vital, growing young city. Its population at the time was 33,500. Many of the buildings in this portion of the map would not survive the year. (Author's collection.)

The first permanent white settlement in present-day Seattle was established in 1851 when a small group stepped ashore from Puget Sound on a beach they named New York Alki (Alki is Chinook jargon for "by-and-by"). The Alki Monument was dedicated at this spot in 1926. Additional plaques, added during the city's 2001 sesquicentennial, included the names of the original settlement's women and children onto the obelisk's base. (SMA no. 46980.)

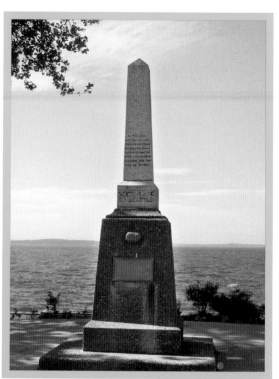

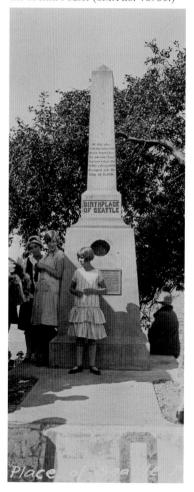

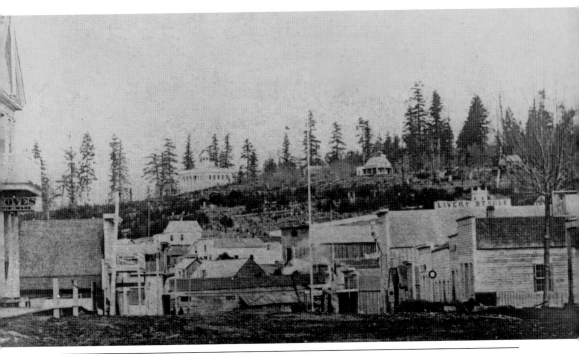

After one miserable winter along Alki's unprotected shores, the settlers sought an inland, deepwater port site. They chose a relatively small flatland along Elliott Bay. Henry Yesler built his steam-powered sawmill on this site. The mill's logs were slid down the original "skid road" (now Yesler Way). A village formed around the mill, shown in this 1861 image by E.M. Sammis. Near the former site of Yesler's wharf is the King County Water Taxi's dock. That boat takes passengers to West Seattle, a short hike from Alki. (WSDA.)

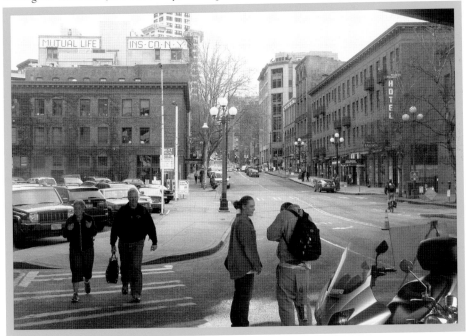

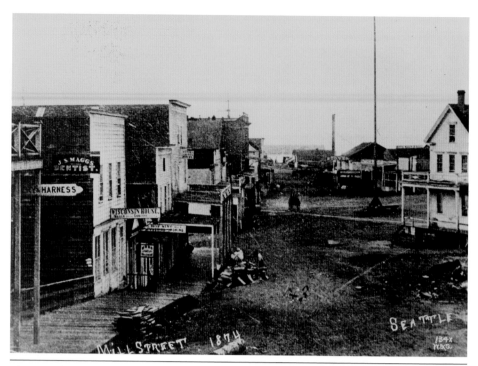

The next three pages depict the young town's early, striving years. Here is Mill Street (now the western end of Yesler Way) in 1874, looking west from Second Avenue to the Elliott Bay waterfront. The smokestack of Yesler's Mill can be seen in the background, just right of the image's center. Just out of the picture to the left were the "lava beds," streets of wide-open saloons and bordellos. (WSDA.)

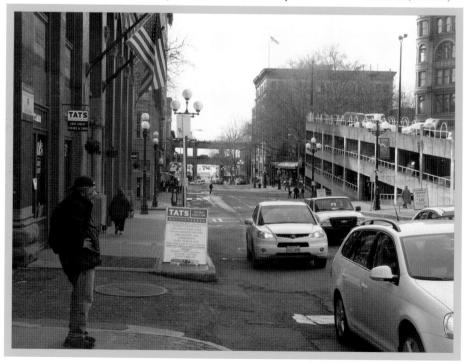

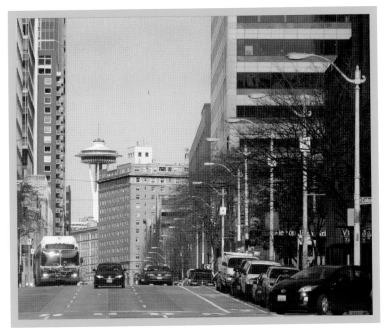

Also from the 1870s is this scene of parade musicians marching down Second Avenue at Columbia Street, past white-picket-fenced homes and mansions. By the early 20th century, Second Avenue had become downtown's principal shopping-and-banking street. The retail core later coalesced around Pine Street, but Second Avenue remains highly commercialized today. (WSDA.)

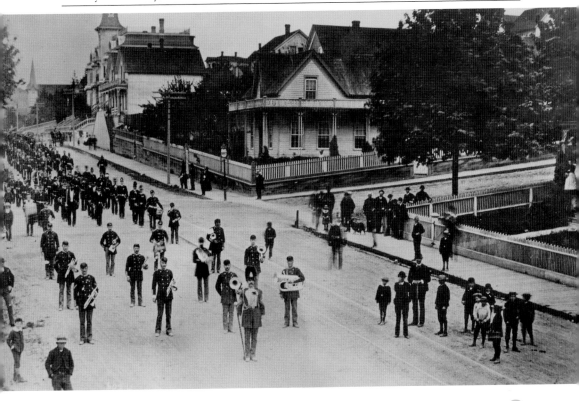

THE PIONEER DAYS

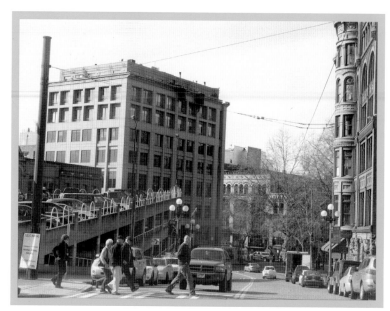

This scene of James Street, looking west from Second Avenue, was photographed by Theodore E. Peiser in 1880. In January 1882, this was the site of a lynching. Its intended target, Ben Payne, had shot David Sires, the first Seattle policeman to die in the line of duty. A street mob stormed the town jail, nabbed Payne and two other prisoners, and executed them on the trees seen in the right of this image. (WSDA.)

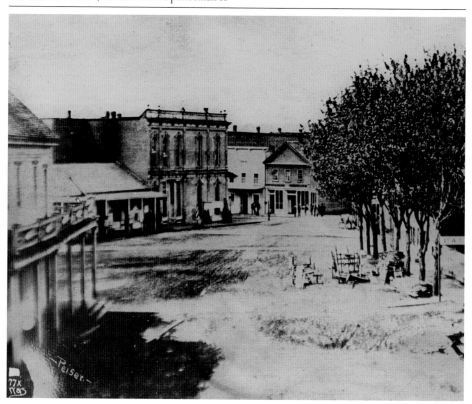

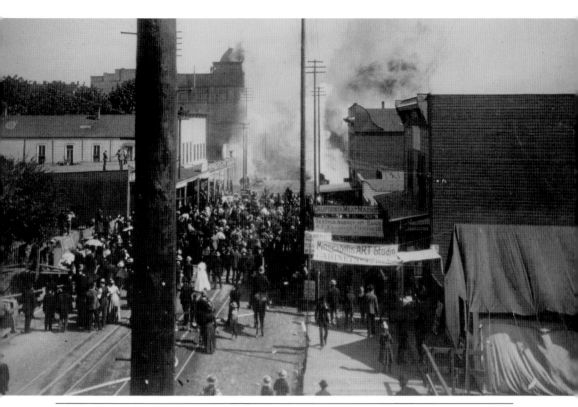

On the dry, windy afternoon of June 6, 1889, a glue pot in a basement cabinetry shop burst into flames. This quickly grew into the Great Seattle Fire. As seen here from First Avenue and Madison Street, the fire consumed all the immediate wood-frame buildings, generating enough heat to destroy adjacent stone-clad structures. (WSDA.)

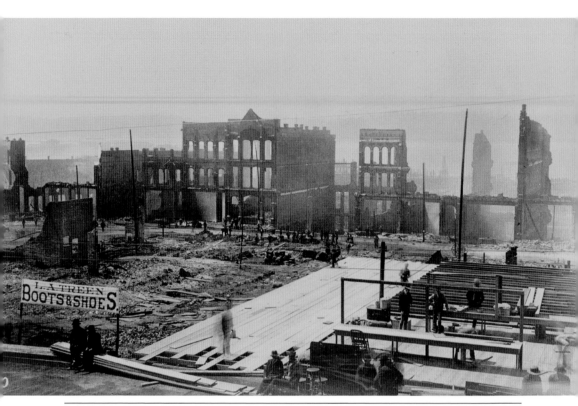

The fire decimated 64 acres of the growing city, including most of its commercial core, as seen here from First Avenue and Yesler Street. Business and governmental activity resumed immediately in hastily pitched tents, buildings, and homes outside the destroyed downtown. Within a year, the stoic stone-and-brick buildings of today's Pioneer Square began to emerge. (WSDA.)

CHAPTER

THE RESHAPED LANDSCAPE

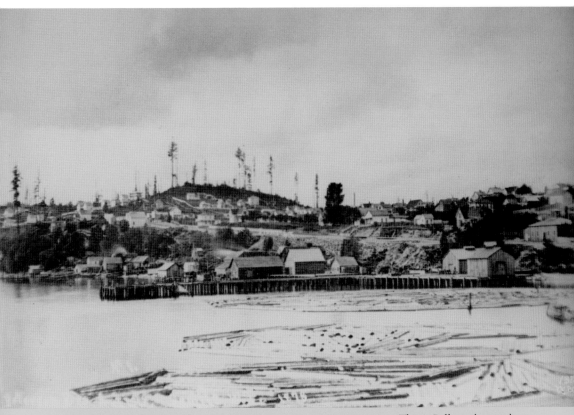

Some of the immediate post-fire commerce came to the Belltown neighborhood, pioneer William Bell's land claim one mile northwest of Pioneer Square. Belltown suddenly had Seattle's only operating hotel after the fire and some of its only operating restaurants. This is Belltown's stretch of Front Street (now First Avenue) in 1874, with the steep slopes of Denny Hill looming over it. The hill would disappear in one of Seattle's many extreme makeovers. (WSDA.)

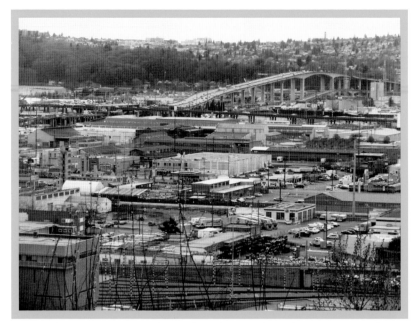

Tide flats originally covered a vast stretch directly south of Pioneer Square, as seen here from Beacon Hill around 1900. Long trestles stood at the present-day sites of South Spokane Street (left to right) and Airport Way South (bottom). By 1906, dirt from hill-reduction projects had turned these wetlands into the bustling Industrial District, since rechristened "SoDo" (for "South of the Dome" or "South of Downtown"). (SMA no. 1.)

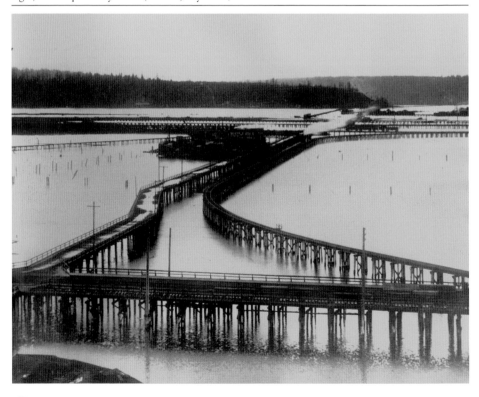

THE RESHAPED LANDSCAPE

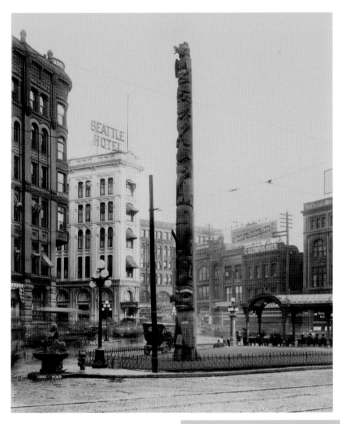

Shortly after Pioneer Square's rebuilding began, the city raised street levels in much of the area to prevent sewer overflows at high tides and to dry up some muddy, soggy roadways. Many new buildings' ground floors became basements and subbasements. These became the topic of Bill Speidel's still-popular Underground Tour. The totem pole and pergola in this 1905 scene were each later destroyed and replaced. The Seattle Hotel was razed in the 1950s for the infamous "sinking ship" parking garage. (WSDA.)

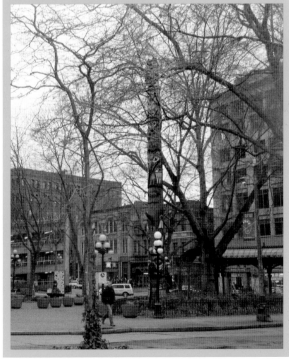

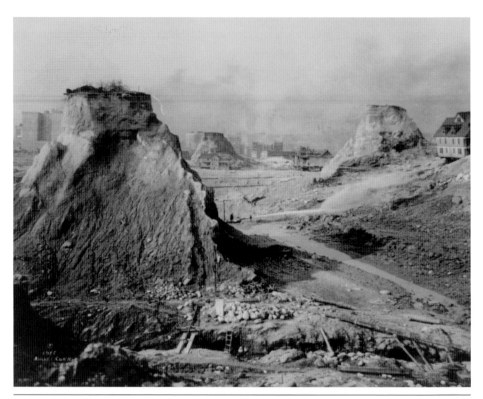

Led by city engineer Reginald H. Thompson, Denny Hill's western half was shoveled away from 1904 to 1911. Several property owners initially refused to let their lands and homes be torn down. Top local photographer Asahel Curtis shot some of these "spite mounds" in 1910. The flattened Denny Regrade became home to warehouses, printing plants, stables, garages, and low-rise apartments. Starting in the 1980s, it attracted high-rise condominiums and fashionable nightspots. (Library of Congress via VS.)

Denny Hill's eastern side between Fifth and Westlake Avenues remained until the late 1920s. This final regrade phase took less time and muscle, thanks to advanced machines that removed and conveyed dirt. The building to the right in the modern image originally housed an engineering firm and is now the flagship store of Top Pot Doughnuts. (SMA no. 3582.)

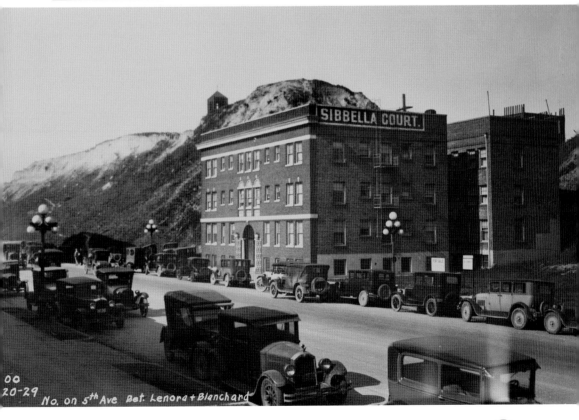

THE RESHAPED LANDSCAPE

Seattle's only real river, the Duwamish, was originally a slow, meandering channel with lots of sharp turns. A straightened, flattened riverbed was created to facilitate shipping and industry—and was promptly polluted by the shippers and industries. This 1914 image depicts the filling in of one oxbow turn to create Duwamish Waterway Park in the South Park neighborhood. (SMA no. 309.)

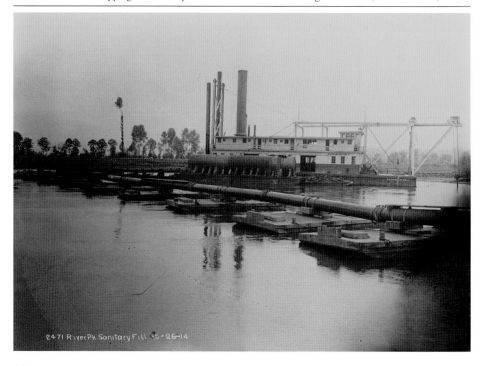

2471 River Pk. Sanitary Fill 5-26-14

THE RESHAPED LANDSCAPE

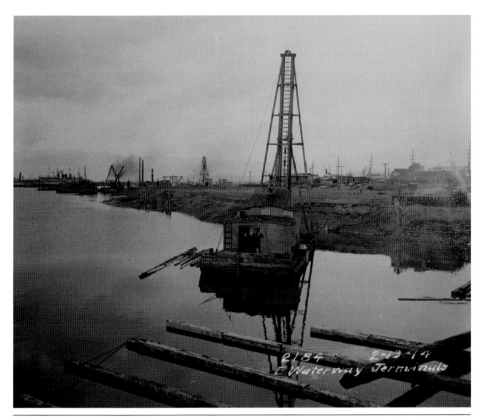

Also in 1914, shovels are rerouting the Duwamish at East Marginal Way South near South Lander Street. Near here in 1907, Standard Oil of California (now Chevron) started what it claims was the world's first full-service gas station. The filled-in land eventually became a container terminal. The large ex-warehouse building to the right in the present-day image houses Starbucks's head office and Sears's oldest existing store. (SMA no. 73.)

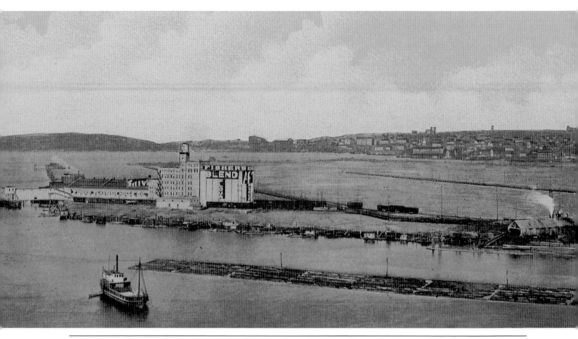

Besides straightening the Duwamish and raising its tide flats, dirt from Seattle's various earthmoving projects was piled up to create Harbor Island at the Duwamish's mouth. The island's first big structure was the Fisher Flouring Mill, the start of a family business empire that now includes KOMO-TV and radio. The mill's now mostly closed; the rest of the island's mostly been redeveloped as container docks. (Port of Seattle.)

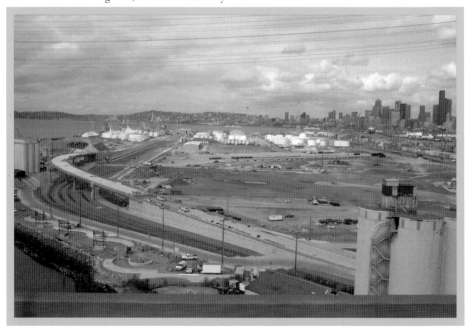

THE RESHAPED LANDSCAPE

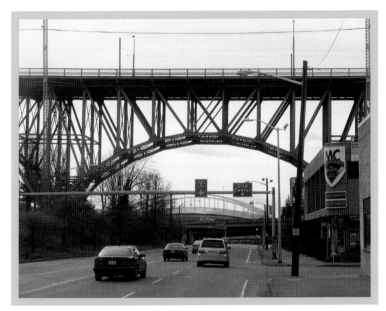

South Dearborn Street is pictured here in 1912, looking west from the Rainier Valley's north end toward Pioneer Square. The wooden bridge above the shovels linked Beacon Hill to the Chinatown/International District, until it collapsed in 1917.

That bridge's steel successor, the Jose Rizal Bridge, still stands. Dearborn's most famous attraction, the main Seattle Goodwill store, lies off the right of the now image. (SMA no. 6070.)

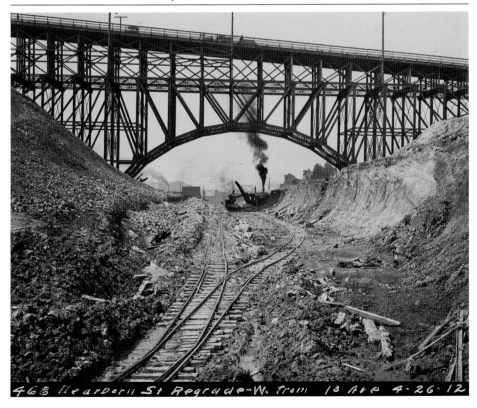

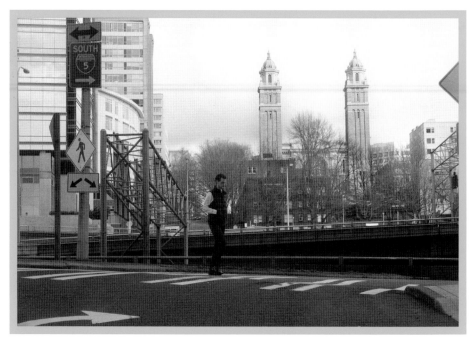

Another seriously lowered street was Sixth Avenue, located on the borderline between downtown and the First Hill residential neighborhood. It is shown here looking east from Marion Street in 1914. All this work would only remain in place for less than 50 years, until Interstate 5's concrete trench bisected much of the city. St. James Cathedral (see page 76) is visible in the modern shot's background. (SMA no. 37.)

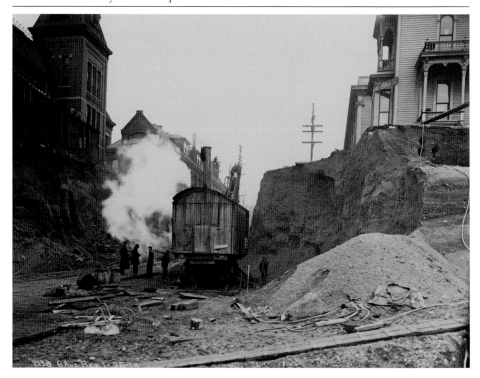

THE RESHAPED LANDSCAPE

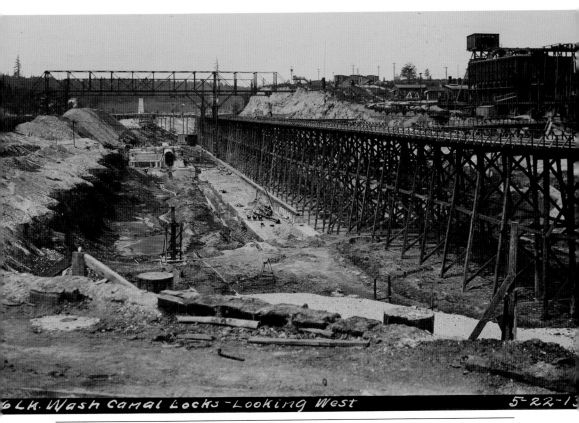

6 LK. Wash Canal Locks - Looking West 5-22-13

One of the city's most elaborate makeovers, the Lake Washington Ship Canal, was devised, and is still run, by the Army Corps of Engineers. Man-made cuts facilitated easy boat transportation between Lake Washington and Lake Union and from there to Puget Sound. Lake levels were regulated by the Hiram M. Chittenden Locks (also known as the "Ballard Locks"), seen here being built in 1913. (SMA no. 6325.)

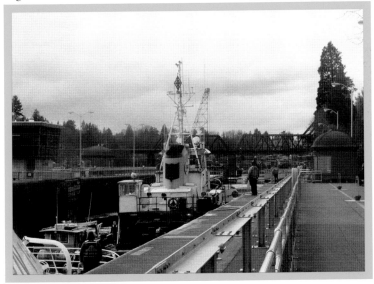

The Reshaped Landscape

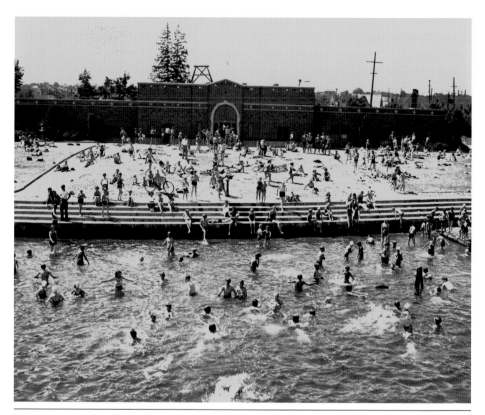

Around the time the ship canal was being built, Green Lake in north central Seattle was also lowered by several feet. The reclaimed land became a vastly popular park, a well-used site for swimming (in season), rowing, bicycling, strolling, and, later, jogging. This 1928 bathhouse, seen here in 1936, has been a live theater space since 1970 and is now leased to the Seattle Public Theater. (SMA no. 10565.)

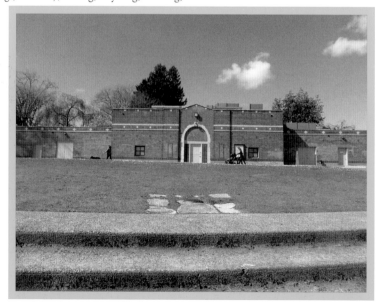

THE RESHAPED LANDSCAPE

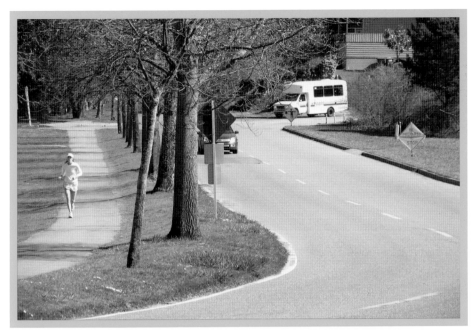

Lake Washington, which forms Seattle's entire eastern boundary, was lowered by several feet as part of the aforementioned ship canal project. A portion of Lake Washington Boulevard South originally traveled over a wooden trestle above a shallow inlet known as Wetmore Slough. This stretch now rests on flatland between Stan Sayres and Genesee Parks, the collective home to Seattle's annual hydroplane boat races. (SMA no. 29548.)

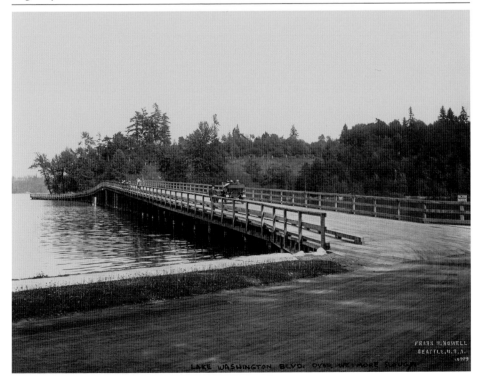

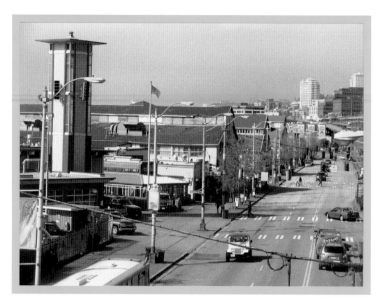

The central waterfront's arterial street was originally Railroad Avenue, a rail trestle on planks, to which auto-truck lanes were later added. Water backwashed under the trestle at high tides. In addition to raising Pioneer Square's streets (see page 21) to counter this backwash, a seawall was installed beneath railroad starting in 1911. Later, a more elaborate seawall project was combined with the filling in and paving of Railroad Avenue, renamed Alaskan Way. (SMA no. 11949.)

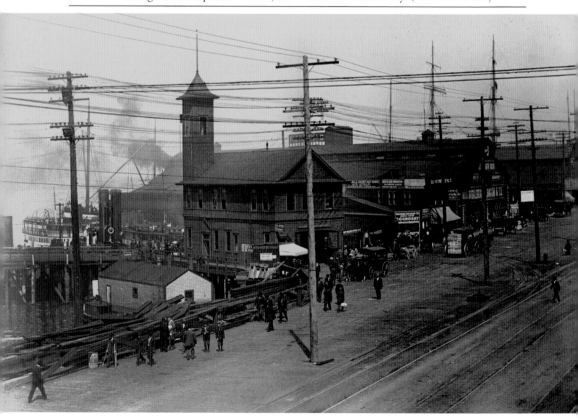

THE RESHAPED LANDSCAPE

CHAPTER 3

GREATER DOWNTOWN

What is now known as the 400 Yesler Building opened in 1908 as Seattle's third city hall. In 1919, the city's executive offices moved out. The renamed Public Safety Building, seen here in 1920, remained home to the city's police and health departments (and an emergency hospital) until 1951, when a new Public Safety Building opened on Third Avenue. The old building lay mostly fallow, until the exterior was restored and the interior was rebuilt in 1977. The new building that had replaced it was razed in 2004; that site remains a hole in the ground. (SMA no. 1754.)

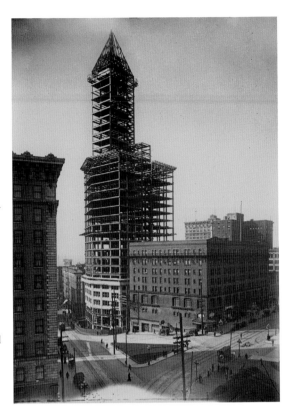

The Smith Tower was built in 1914 under the aegis of typewriter king L.C. Smith. For publicity reasons, he wanted the tallest building outside New York. Smith's designers achieved his goal by sticking a narrow 14-story tower segment atop 21 main office floors, topped in turn with a decorative Gothic pyramid. Most recently restored in 1999, it still bears six original, manually operated Otis elevators. The pyramid segment is now a private residence. (SMA no. 11930.)

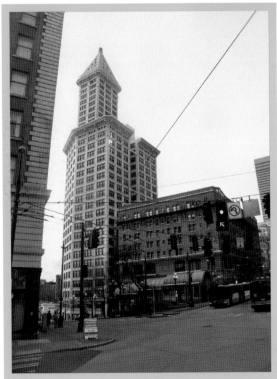

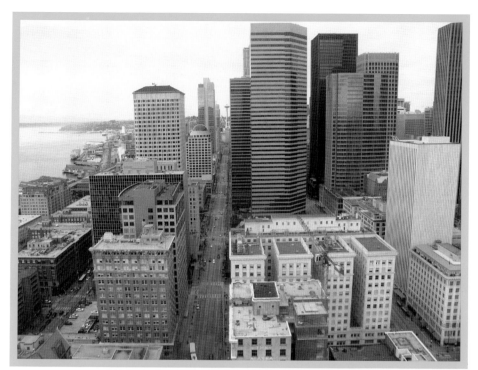

The Smith Tower remained downtown Seattle's tallest building until 1968. Its Chinese Room observation deck and banquet hall is where Asahel Curtis captured this streetscape in 1918 for *Argus*, a local business weekly. Most of the blocks immediately north of the tower would remain largely unchanged for the next five decades, except for the addition of parking garages and the removal of trolley tracks. (VS and Pacific Publishing.)

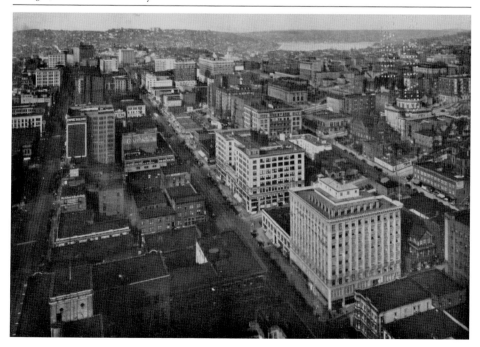

This 1912 postcard shot looking up First Avenue also promotes the Golden Potlatch Festival. Business boosters staged this series of parades and community events from 1911 to 1914 and again from 1935 to 1941. The event's name and iconography evoked the Alaska gold rush heritage and Native American archetypes (and/or stereotypes). After World War II, the idea of a citywide festival was revived as the still-running Seafair. (VS.)

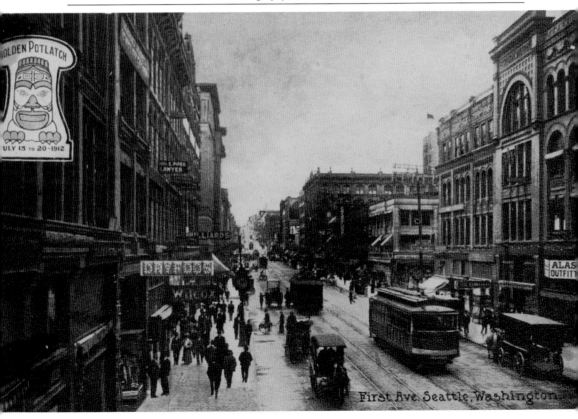

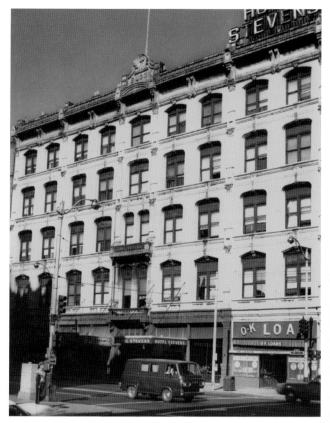

On this page and next, street-scene photographer Werner Lenggenhager documents two of the buildings that would be razed in 1971 for the Seattle (now Henry M. Jackson) Federal Building. Here, the Hotel Stevens on First Avenue opened in the late 1890s. It remained open, albeit not at its onetime elegance, into the 1960s, when this shot was taken just before its closure and demolition. (WSDA.)

On the Second Avenue side of the same block, the Romanesque revival Burke Building was constructed in phases from 1889 to 1891. Preservationists fought in the early 1970s to save the Burke from the wrecking ball and lost. In a compromise, its stone arch and a few other flourishes became public-art adornments on the rebuilt site. (WSDA.)

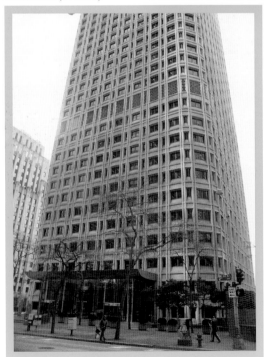

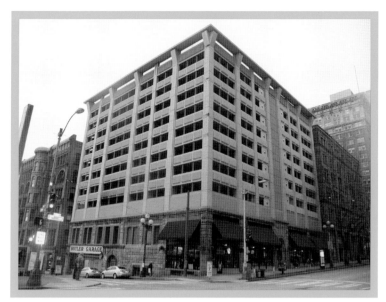

The 1890-built Hotel Butler was one of the first major post-fire structures. It was planned as an office building; the Seattle City Council operated for a year in a fifth-floor meeting room. In the 1920s, its Rose Room restaurant was a notorious Prohibition-defying speakeasy. The hotel closed in 1933. Its lower facade was retained at the bottom of the parking garage that soon replaced it. (VS.)

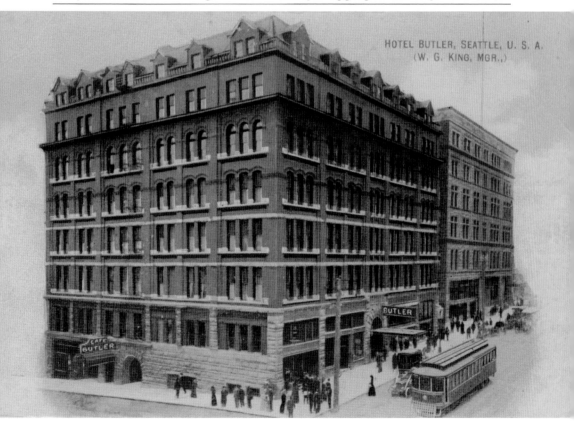

HOTEL BUTLER, SEATTLE, U. S. A.
(W. G. KING, MGR.)

As mentioned on page 15, Second Avenue was Seattle's retail anchor during the early 20th century. By 1944, the city's biggest department stores (Frederick & Nelson and the Bon Marché) had moved to Pine Street. But Second Avenue still had Penney's (in the Bon's former building), Rhodes of Seattle, and McDougall-Southwick. In 2011, Target is set to open on the former Penney's block. (SMA no. 40330.)

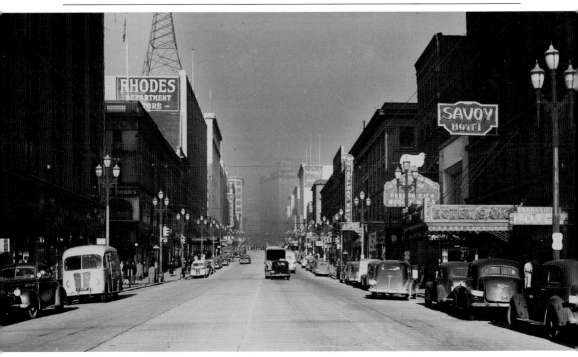

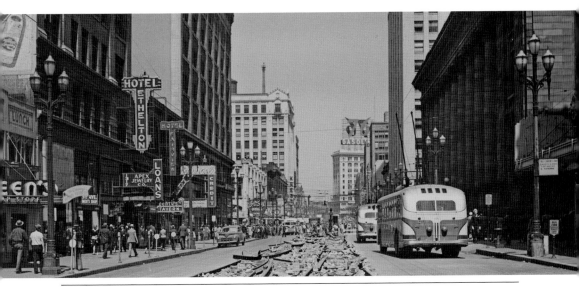

This 1943 shot depicts Third Avenue, looking north from University Street. Former trolley tracks are being torn up as part of a World War II scrap-metal drive. The electric buses that replaced the trolleys are seen at curbside. Even without the trolleys, Third Avenue was traditionally a working-class street of five-and-dime stores and credit jewelers. To the left in the present-day shot is Benaroya Hall, home to the Seattle Symphony since 1998. (SMA no. 40110.)

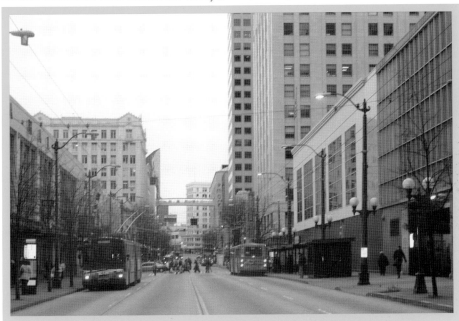

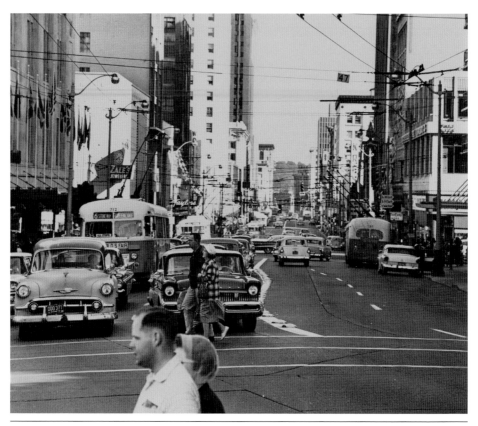

Here is Third Avenue looking south toward Pine Street, as captured in 1962 by prominent news photographer Phil H. Webber. One of the trolley buses to the left bears a sign announcing a stop at the world's fair. This stretch of Third Avenue has retained its populist feel with such merchants as Radio Shack, Walgreens, and Ross, and even more bus routes than it bore in the 1960s. (WSDA.)

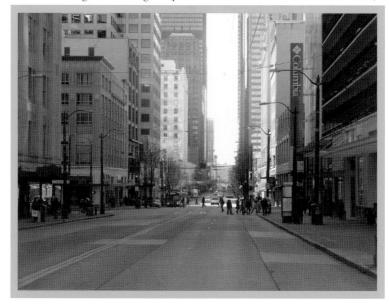

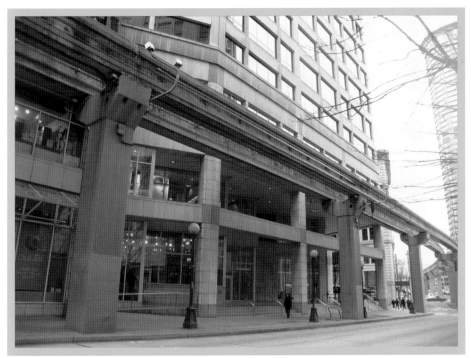

The 1962-built world's fair monorail had its downtown terminus at the triangle of Westlake Avenue, Fourth Avenue, and Pine Street. The half-block across Pine Street from the station was Westlake Mall, a mostly barren plaza underneath the elevated tracks. This plaza was bordered by a short retail strip, whose original occupants included a souvenir stand and a wax museum. In 1996, these two blocks were redeveloped as Westlake Center, with an office tower, a mall, and an uncovered paved park. (SMA no. 41057.)

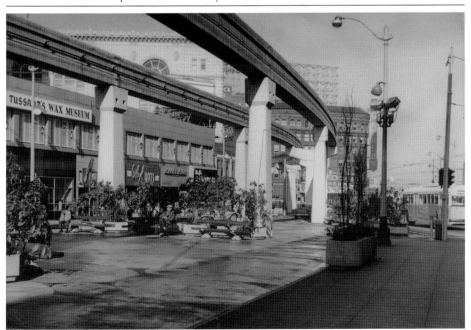

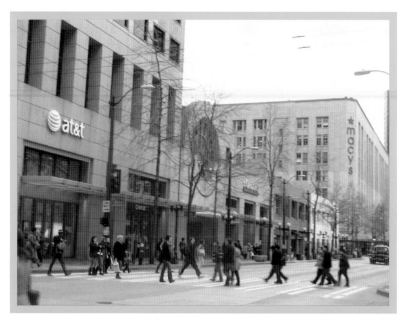

Fourth Avenue is seen looking north from Pike toward Pine in 1948. To the right is the Bon Marché department store, which moved into this ornately flourished edifice in 1929. Four more floors were added to the building in the 1950s. In 2005, the Bon was one of many regional chains that lost their historic identities, when owner Federated Department Stores stuck the Macy's brand on their stores and products. (SMA no. 41057.)

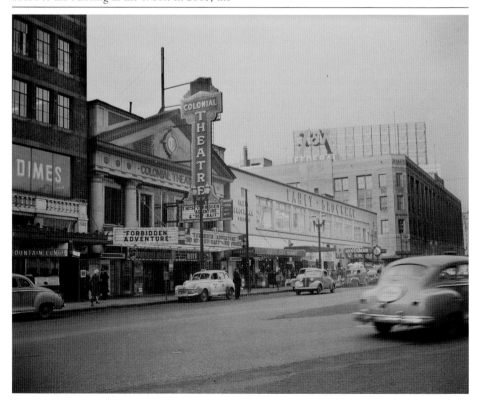

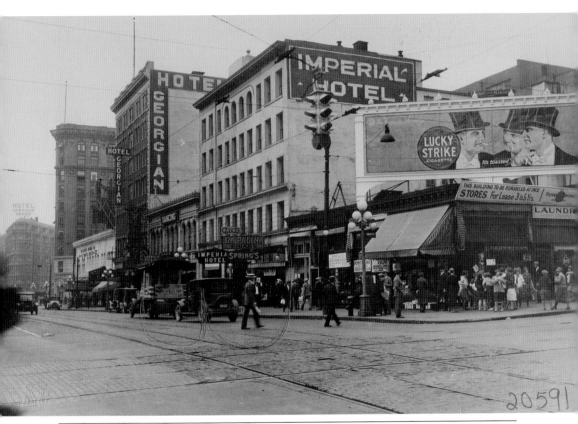

20591

This is Fourth Avenue a block south and several decades earlier, looking up from Union Street in Frank Jacobs's 1920s photograph. The Men's Wearhouse store in the modern image originally housed regional offices of the Great Northern Railroad. The Northern Trust financial office midway up the block had been the head office of Peoples National Bank, founded by local steamship mogul Joshua Green. (WSDA.)

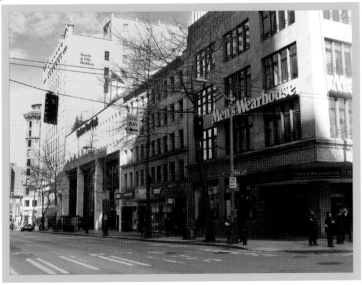

The Olympic Hotel at Fourth Avenue and Seneca Street was built in 1924 by local business leaders who felt Seattle needed a world-class hostelry. It became the flagship of the Western International (now Westin) chain; the property has since been resold twice and is now the Fairmont Olympic. Just beyond it in this 1966 image is the equally elegant White-Henry-Stuart Building, razed in 1974 and 1975. (SMA no. 43609.)

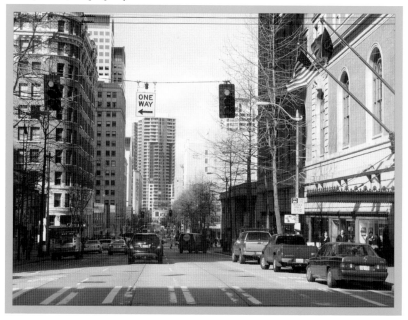

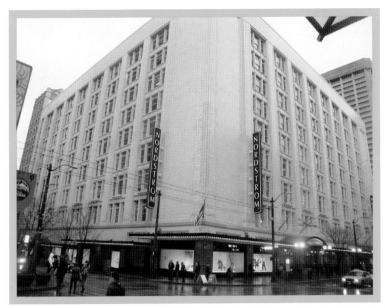

Frederick & Nelson (F&N) first opened in 1890 as a furniture store. It had become Seattle's most prestigious department store by 1912 when it built an Edwardian edifice at Fifth Avenue and Pine Street. This huge Christmas exterior display was put up in 1948, three years before the building was expanded five floors taller. F&N closed in 1992 following decades of out-of-state mismanagement. Nordstrom moved into the building six years later. (Julie D. Pheasant-Albright.)

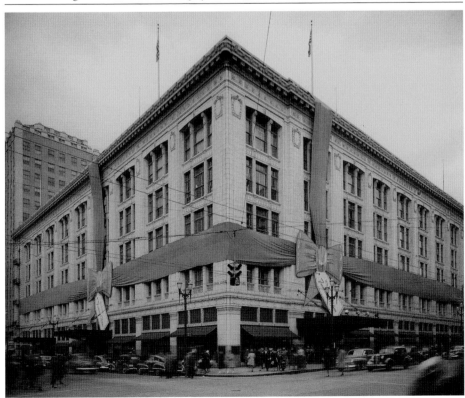

The Coliseum Theater at Fifth Avenue and Pike Street was 24 years old in 1942 when this photograph was taken. Designed by renowned theater architect B. Marcus Priteca, it was billed as the first building in America specifically built to exhibit motion pictures (that claim was also made on behalf of several other theaters around the country). A 1990 revamp preserved the outside while turning the inside into a Banana Republic. (VS.)

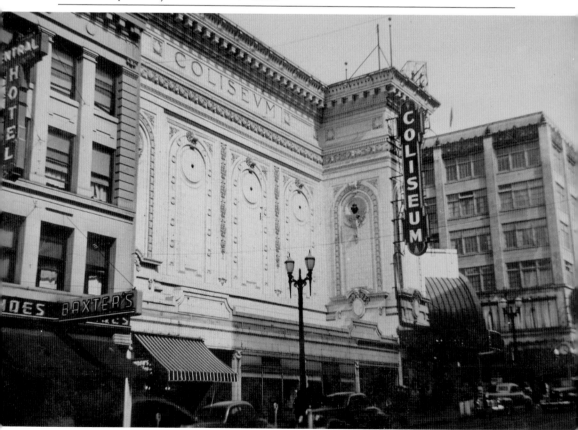

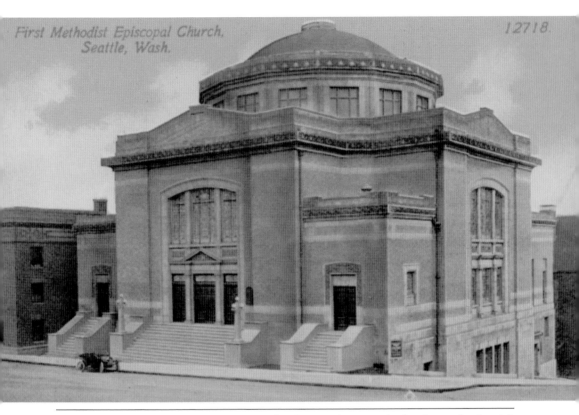

12718.

First Methodist Episcopal (later First United Methodist) Church opened at Fifth Avenue and Marion Street in 1908. The congregation itself, established in 1853, is Seattle's oldest. The building features a 66-foot ceiling under an orange-tiled dome. In the 1990s, the church wanted to demolish it and sell the land to developers, but preservation officials intervened. Now, a tower is going up next to the preserved building; the church has moved to smaller quarters on Denny Way. (VS.)

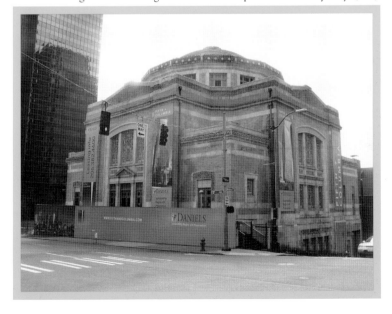

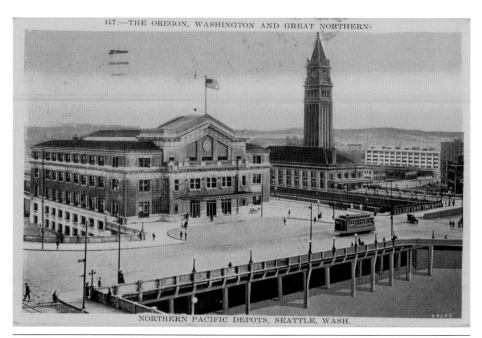

457:—THE OREGON, WASHINGTON AND GREAT NORTHERN-

NORTHERN PACIFIC DEPOTS, SEATTLE, WASH.

Seattle's train depots, Union Station (home to the Union Pacific and Milwaukee Road) and King Street Station (Great Northern and Northern Pacific) were both in place by 1911. King Street's clock tower is a replica of the Campanile di San Marco in Venice, Italy. Union Station was bought and restored by Microsoft cofounder Paul Allen; King Street is undergoing a city-managed renovation to replace an ugly pre-Amtrak modern interior with its older elegance. (VS.)

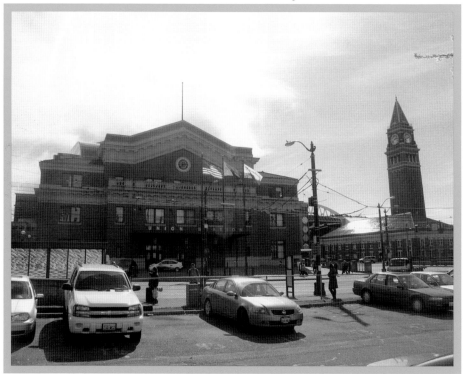

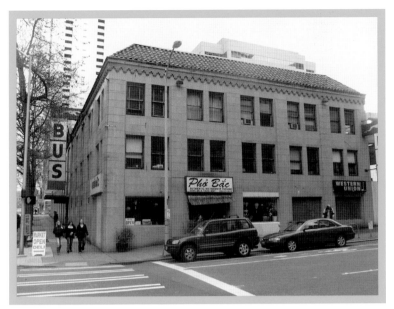

The Seattle Central Terminal on Stewart Street was opened in 1928 by the North Coast Transportation Co. and Pacific Northwest Traction Co., two of the regional bus companies that eventually merged into Greyhound. Plans in the mid-2000s to replace the station with a high-rise tower were scuttled, at least for the time being, by the 2008 real estate crash. (WSDA.)

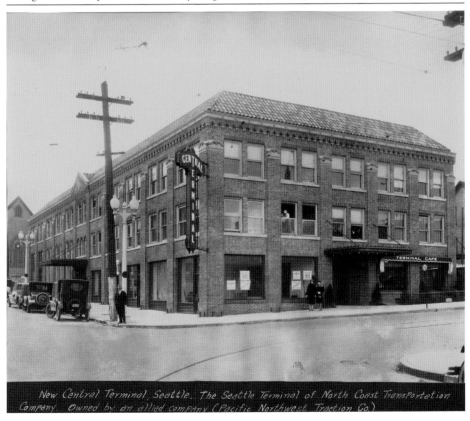

When this photograph was taken in 1915, the triangular lot at Sixth Avenue, Westlake Avenue, and Virginia Street (between downtown and south Lake Union) sported walls clad in several lively billboards while the plat awaited development. Now, the block bears the mark of a single world-famous brand. (SMA no. 603.)

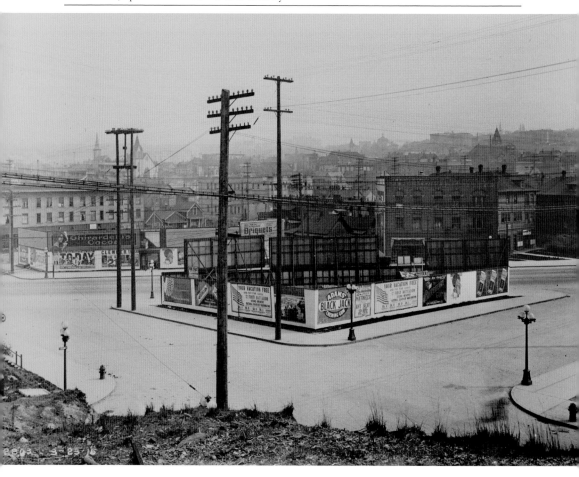

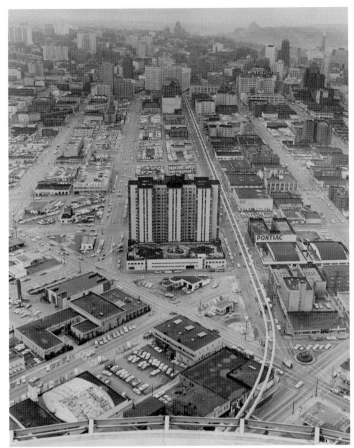

At its 1962 opening, the Space Needle (see page 85) looked over the often-forgotten Belltown/Denny Regrade area. World's fair organizers built a monorail line along Fifth Avenue to send fairgoers to the downtown retail core, bypassing the Regrade's low-rent blocks. Today, there's a lot more in the Space Needle's immediate vicinity, leaving the high-rise Grosvenor House (now Archstone) apartments a little less lonely. (WSDA.)

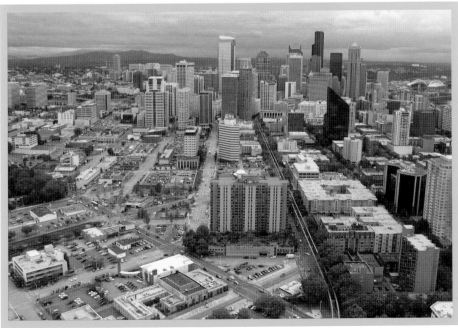

This modest 1904 low-rise hotel and set of storefronts at 2013 First Avenue became one of the sacrifices to Belltown's later growth. By 1988, the building had given way to a sleek 17-story office and condominium tower with four stylish boutiques at its street level. Some of its residential units have resold during the 2000s for as much as $6 million. (SMA no. 31569.)

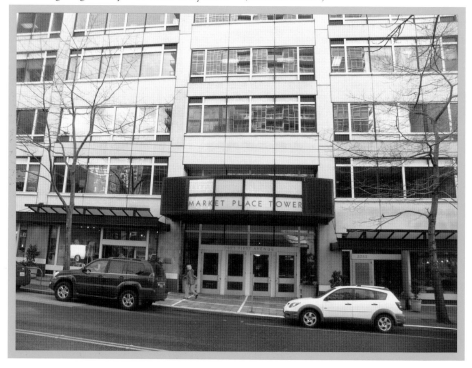

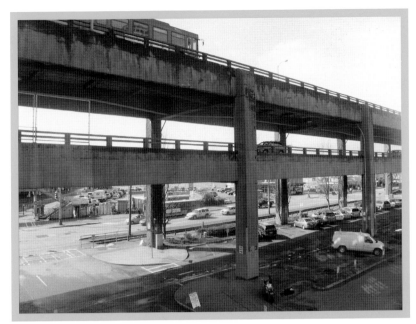

The filled-in Railroad Avenue on the central waterfront (see page 32) is here seen looking northward from Marion Street in 1934. Note the concrete lane closest to the water, part of the second seawall project. This was considered a working waterfront—a place for industry, not for leisure or tourism. When the double-deck Alaskan Way Viaduct was built atop loose fill dirt in 1951, politicians did not think they were obstructing any particularly scenic views. (SMA no. 8607.)

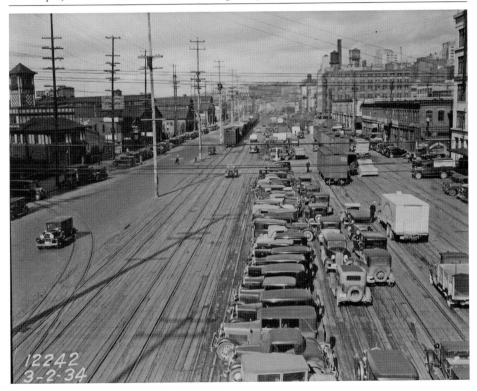

Fifth Avenue South and South Jackson Street is a key intersection in what was then called Chinatown and later officially retitled the Chinatown-International District. Seattle's smaller first Chinatown was three blocks to the west but was razed for new streets leading to the train stations (see page 50)—Chinese immigrant labor had built much of the west's rail lines. A decade after this 1933 picture was taken, the Japanese-American storefronts would be shuttered under the World War II relocation. (SMA no. 51393.)

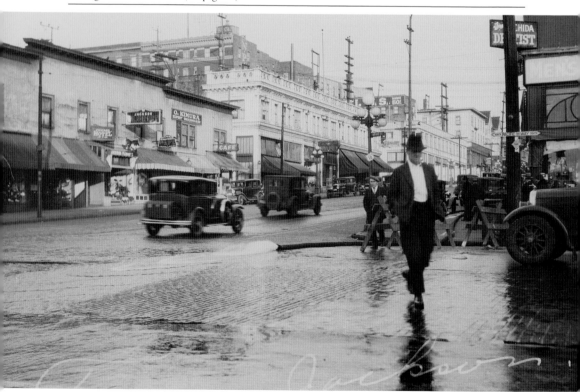

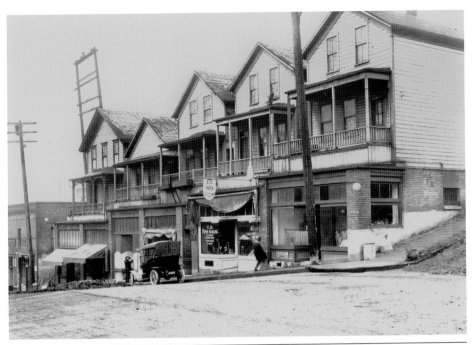

South Main Street (at the International District's northern edge) was lowered in the early 20th century. At that time, new storefronts were built beneath some existing row houses, as seen here in 1915. More recently, the city has turned the steep hillside north of Main into Kobe Terrace Park, named for Seattle's Japanese sister city. (SMA no. 50662.)

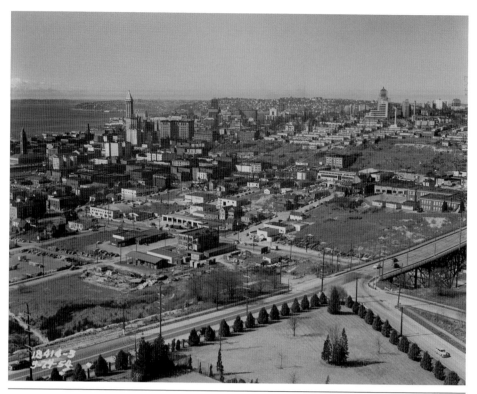

The top of Beacon Hill's north slope (now known as Jose Rizal Park) has long been a popular vantage point for downtown skyline shots. This one comes from 1954, after the Japantown east of Chinatown was cleared during World War II (some of it was replaced with military and Boeing-worker housing), but before Interstate 5's ribbons of concrete came in. (SMA no. 45545.)

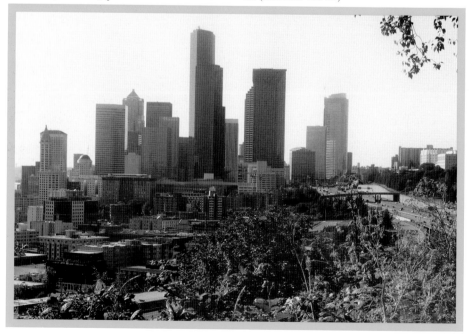

GREATER DOWNTOWN

THE NEIGHBORHOODS

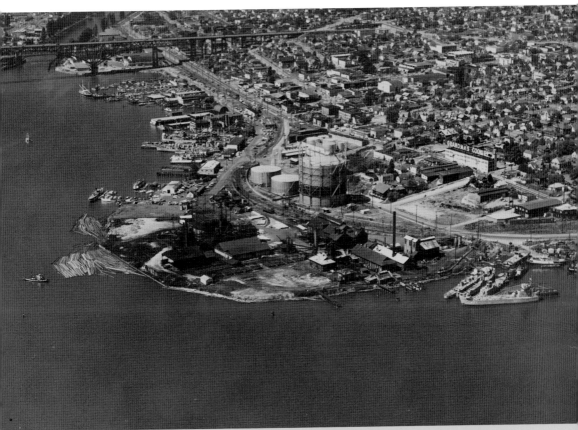

The Washington Gas Company (GASCO) ran a coal and oil gasification plant on Lake Union's north shore from 1907 to 1956 (when natural-gas pipelines reached Seattle). The city took over the property in 1963. After partial demolition and soil decontamination, Gas Works Park opened in 1974. It's now home to the city's annual Fourth of July fireworks show. (SMA no. 29077.)

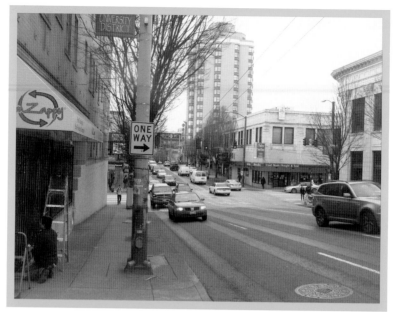

Northeast 45th Street and University Way Northeast, seen here in 1956, is the main intersection of the "U District," just west of the University of Washington (UW) campus. All the buildings in the earlier shot are still standing, except the National Bank of Commerce branch (a plainer Key Bank is there now). The Edmond Meany (now Deca) Hotel's novel design provides every guest room a corner window. (SMA no. 61138.)

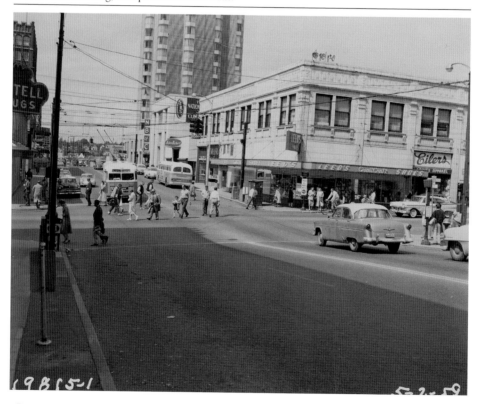

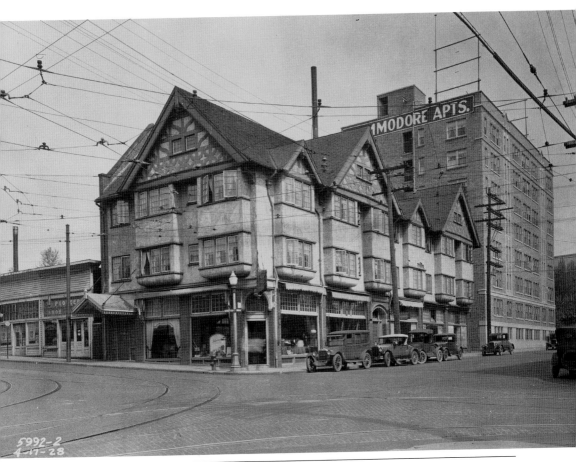

University Way's southern end has been marked since 1909 by the College Inn building. It was built as a hotel for visitors to the Alaska-Yukon-Pacific Exhibition (see page 86). It was designed by leading local architect John Graham Sr. (1973–1955), who also worked on everything from churches and office buildings to Northgate Mall; his firm later helped create the Space Needle. The inn now offers 27 European-style guest rooms above ground-floor retail spaces, which are above a basement pub. (SMA no. 2888.)

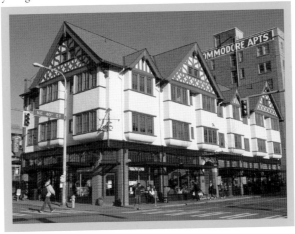

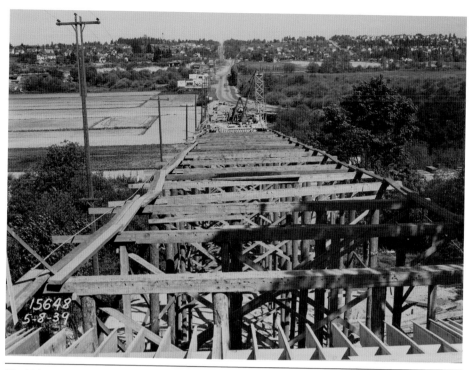

The 45th Street Viaduct was first built during 1938 and 1939 heading steeply downhill from the U District. It originally led toward an area of small farms and a city dump. The fashionable Laurelhurst neighborhood, University of Washington athletic fields, and the University Village shopping center are there now. The viaduct's been partly or wholly rebuilt four times, most recently in 2010. (SMA no. 38898.)

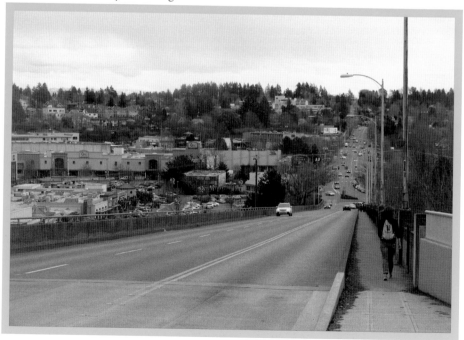

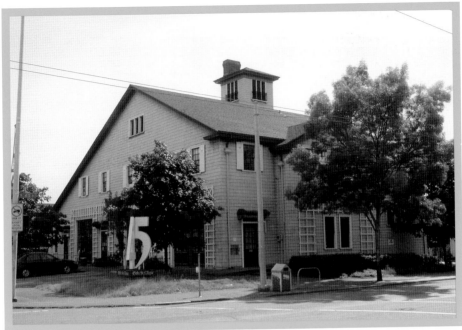

The mostly residential Wallingford neighborhood, west of the U District and north of the gas works, was originally a streetcar suburb platted by developer John Wallingford. The area received this new fire station on Northeast 45th Street in 1914, designed by Daniel Riggs Huntington. The building, which later became a police precinct and a library, now houses a community health clinic. (SMA no. 4.)

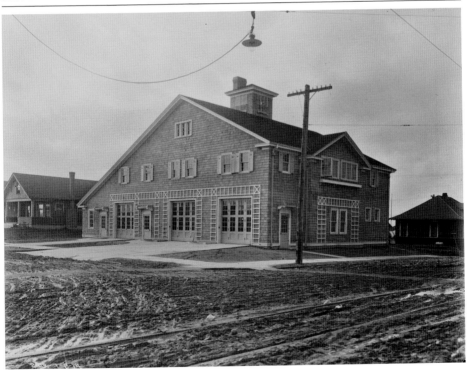

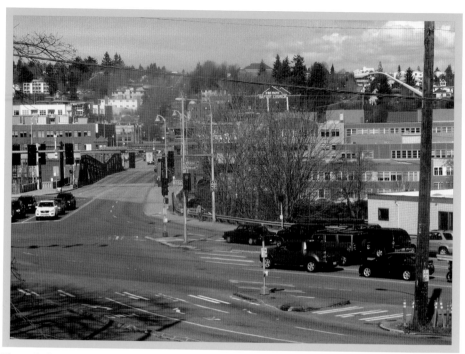

This is the first Fremont Bridge's south side in 1915, surrounded by horse stables and other then-vital industries. A newer drawbridge opened two years later. That bridge remains the centerpiece of what local boosters call "the Center of the Universe," now an area of funky shops and live music clubs. (SMA no. 587.)

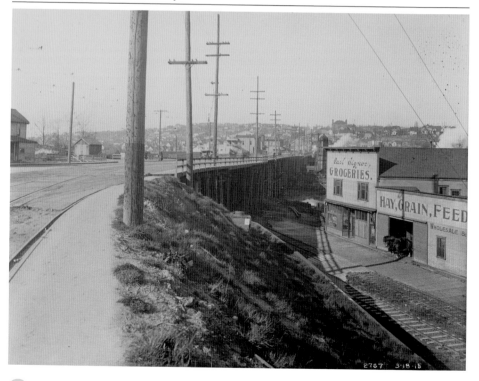

THE NEIGHBORHOODS

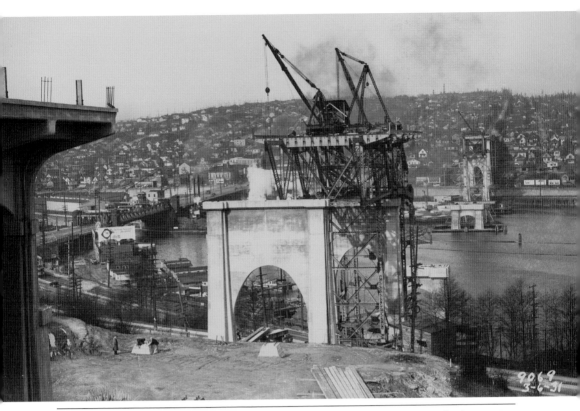

In the early 1930s, the state finished building Washington's part of the Pacific Highway (also known as US Highway 99). Highlighting the project's last phase was the George Washington Memorial (also known as Aurora) Bridge, opened in February 1932. Almost 3,000 feet long, it rises 167 feet above Lake Union's northwest corner. Eight-foot-tall fences were added on both sides in 2010, intended to deter would-be jumpers. (SMA no. 4819.)

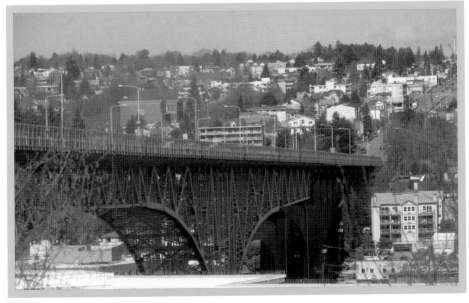

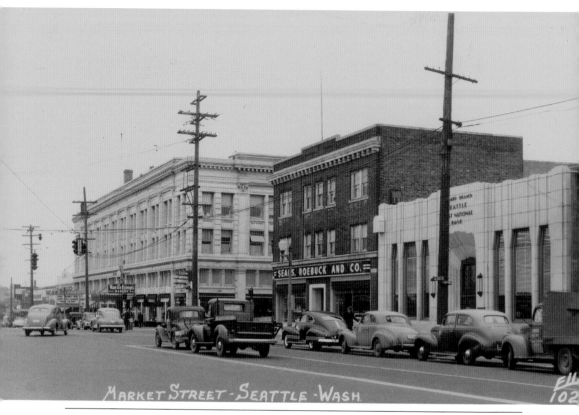

MARKET STREET - SEATTLE - WASH.

The Ballard district began as a separate town around Salmon Bay's fishing docks and shingle mills. Its main drag, Northwest Market Street, is seen here in about 1948. The Sears building that now houses a coffee shop and apartments was originally a mortuary. The Ballard Building down the next block originally housed an Eagles lodge, which became the Bagdad Theater and, later, the Backstage nightclub. It is now home to shops, offices, and restaurants. (Julie D. Pheasant-Albright.)

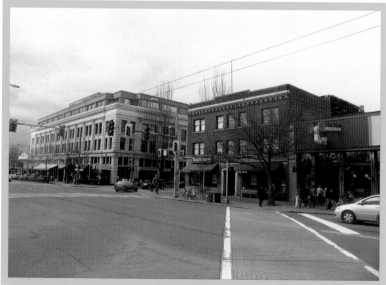

THE NEIGHBORHOODS

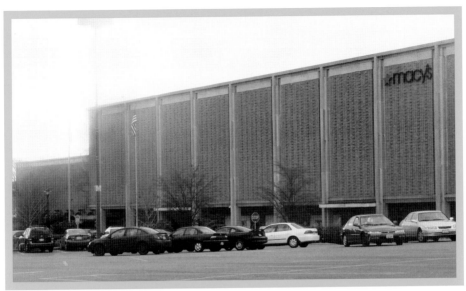

America's first major suburban shopping mall was built in 1950 and designed by key local architect John Graham Sr., Northgate. This 1960 view from its east side displays Northgate's anchor tenant, the Bon Marché (whose then-owner Allied Stores built the center). A 1975 remodel replaced this fashionable wall of glass with plain brick; three decades later, the Bon's name also went away (see page 44). (SMA no. 63734.)

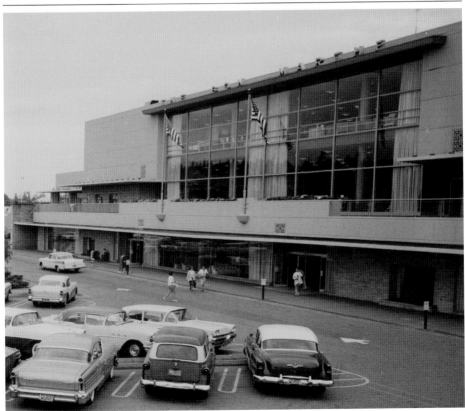

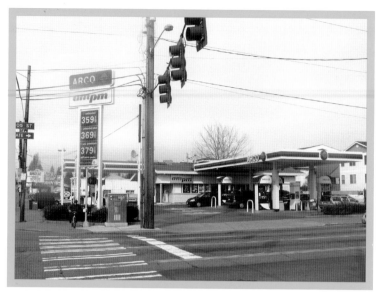

From the 1930s to the 1960s, Aurora Avenue North (see page 65) was the chief highway through, to, and from Seattle. When Interstate 5 came along, Aurora became an arterial street of budget-minded shops and motels. The intersection of Aurora and North 105th Street was a mile beyond Seattle's city limits in 1947 when this Richfield gas station and its mascot eagle sign were photographed. The station has been rebuilt but is still franchised to Richfield's successor brand, ARCO. (SMA no. 73831.)

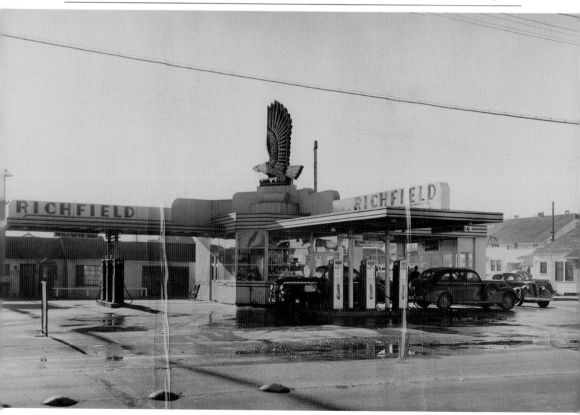

THE NEIGHBORHOODS

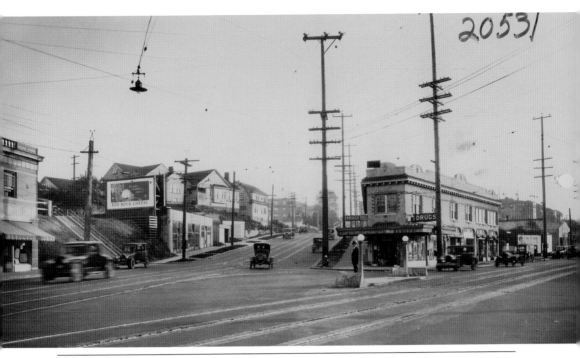

Eastlake Avenue East and Harvard Avenue East at Capitol Hill's north end is a busy crossroads between the Hill, the U District, Lake Union, and downtown. The intersection was photographed by Walter P. Miller in 1926. The commercial building on the left is still there, but the triangular drugstore was razed in 1959 for the southern pillars of the Interstate 5 Lake Washington Ship Canal Bridge. (WSDA.)

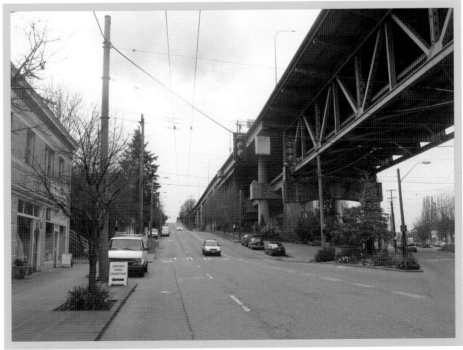

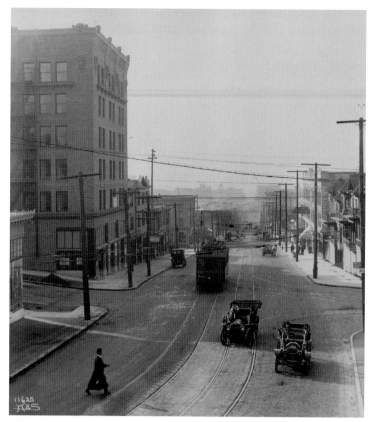

This c. 1902 image of Upper Pike Street, part of the Pike/Pine Corridor linking downtown to Capitol Hill, was captured by the prolific Webster & Stevens photographic firm. As automobiles went mass-market starting later that decade, the Pike/Pine Corridor emerged as Seattle's first auto row of dealerships and repair shops. A few car showrooms remain, but it's now better known for hip bars, nightclubs, and shops. (WSDA.)

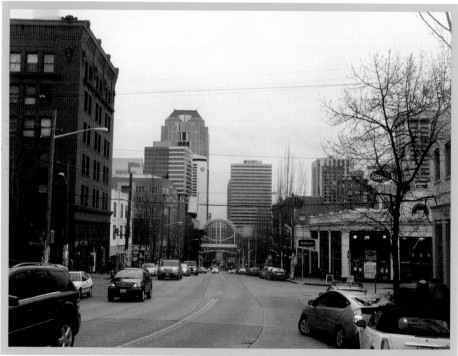

THE NEIGHBORHOODS

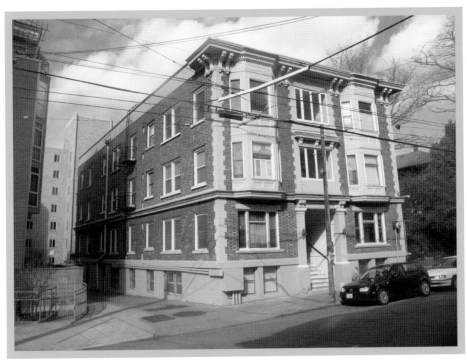

Capitol Hill, along with other close-in neighborhoods such as First Hill and Queen Anne, is known for its elegant old apartment buildings. Hundreds of these have retained what modern advertising calls old-world charm for as long as 100 years. The Coronado Apartments at 115 Bellevue Avenue East (shown here c. 1920) is now the resident-owned Troy Co-Op. (VS.)

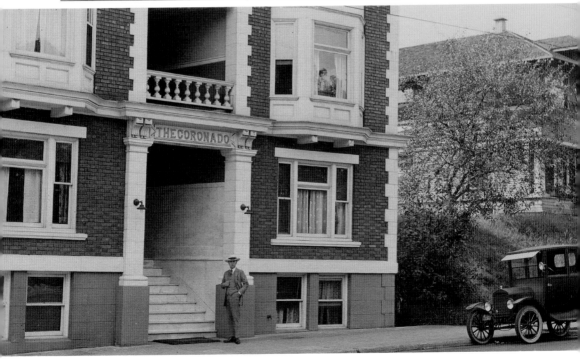

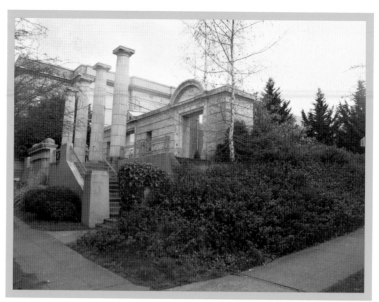

Temple de Hirsch, Seattle's first Jewish Reform congregation, began in 1899. It was named after British Jewish philanthropist Baron de Hirsch. A more modern synagogue opened in 1960 on the other side of its Capitol Hill block, now called Temple de Hirsch Sinai (following a merger with a suburban congregation). This original 1908 building was razed in the 1990s; portions are preserved as a monument and plaza. (VS and Deran Ludd.)

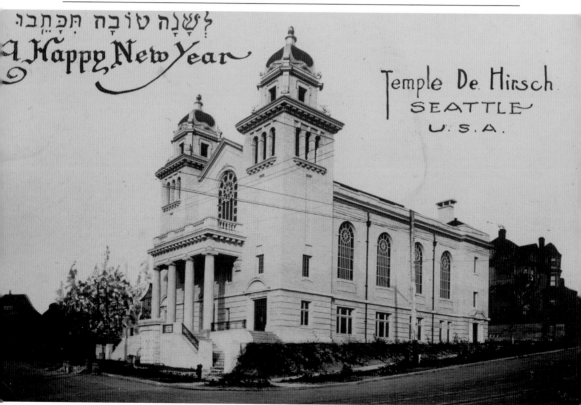

THE NEIGHBORHOODS

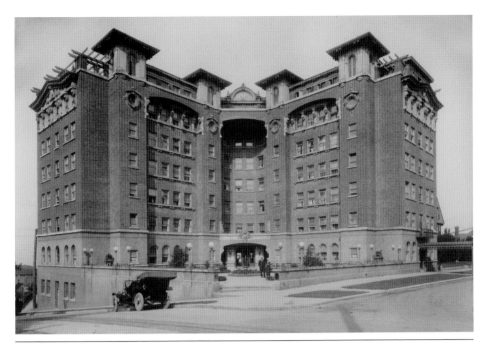

Besides the College Inn (see page 61), the Sorrento Hotel on First Hill was also built in 1909 to welcome Alaska-Yukon-Pacific (AYP) Exposition visitors (see page 86). Its stately fireplace lounge and Hunt Club banquet room were already in place when the boutique hotel revival of the 1990s came along. Recently, literary readings have joined live lounge music on its schedule of entertainment attractions. (VS.)

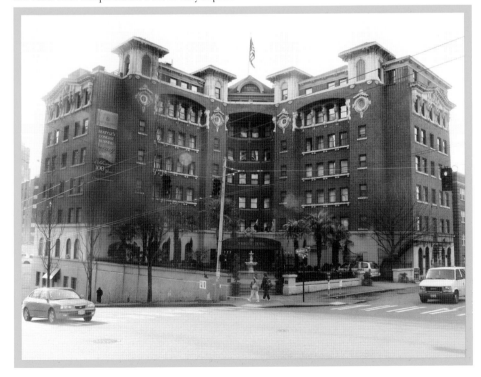

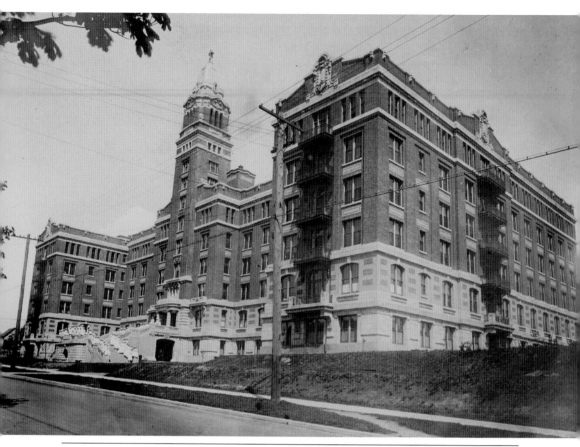

Providence Hospital, managed by an order of nuns, was once Seattle's largest women-owned business. Seattle's first hospital, Providence was established downtown in 1876. In 1911, it moved into a brick complex on Cherry Street in the Central District. Swedish Medical Center took over the building in 2000 and renamed it the Swedish Cherry Hill Campus but kept the neon-lit cross atop its central spire. (VS.)

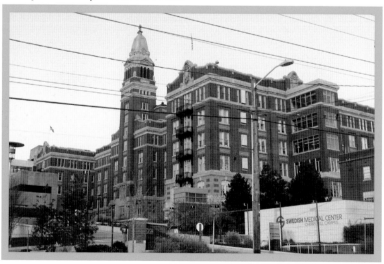

THE NEIGHBORHOODS

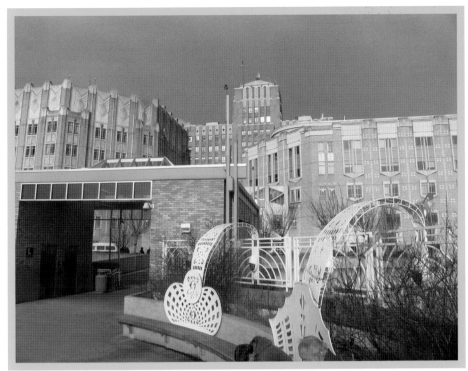

First Hill has long been nicknamed "Pill Hill," the site of three of Seattle's five major hospitals. The most classical looking of these hospitals is Harborview Medical Center. Owned by King County and managed by the University of Washington, its art deco main building opened in 1931. Newer additions have obscured its original lines but complement its sleek modernity. (VS.)

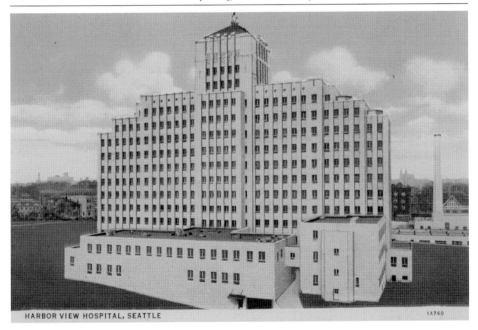

HARBOR VIEW HOSPITAL, SEATTLE 1A760

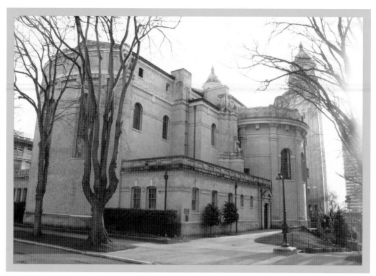

St James Cathedral on First Hill, seen here from the back, is home parish to the Catholic Archdiocese of Seattle. First opened in 1907, it was been significantly renovated in 1916 (with a flat roof replacing a dome that had collapsed from heavy snow), 1950, and 1994 (after a fire gutted much of the interior). During the latter remodel, the cathedral's altar was moved from the room's east end to its center. (Washington State Historical Society via VS.)

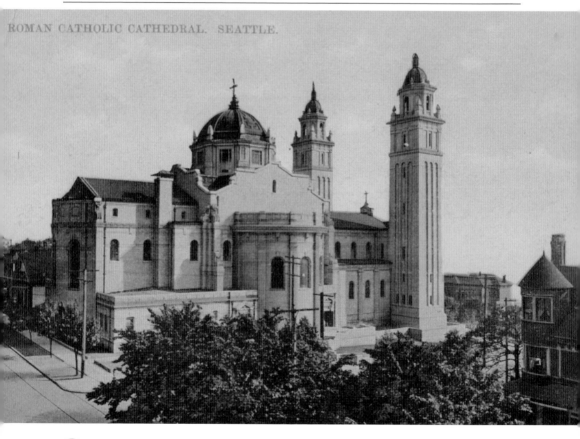

ROMAN CATHOLIC CATHEDRAL. SEATTLE.

THE NEIGHBORHOODS

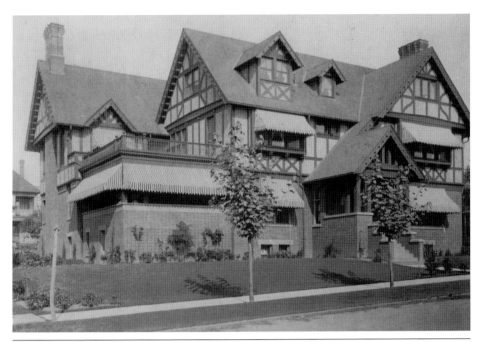

First Hill's Stimson (later Stimson-Green) mansion was built in 1901 by C.D. and Harriet Stimson, whose family was big in timber, real estate, and, later, broadcasting (KING-TV). Steamship/banking baron Joshua Green bought it in 1915. The Stimsons' granddaughter Patsy Collins owned it from 1975 to 2001 before donating it to the Washington Trust for Historic Preservation. Its English Tudor exterior contains interior rooms done up in assorted eclectic styles. It's a popular rental space for weddings and other events. (VS.)

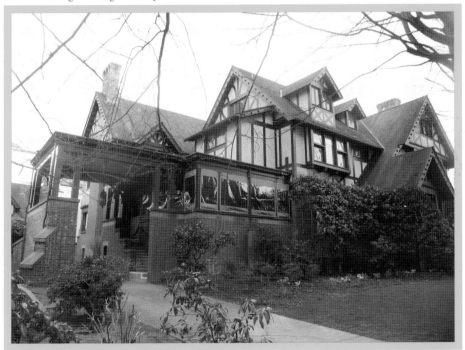

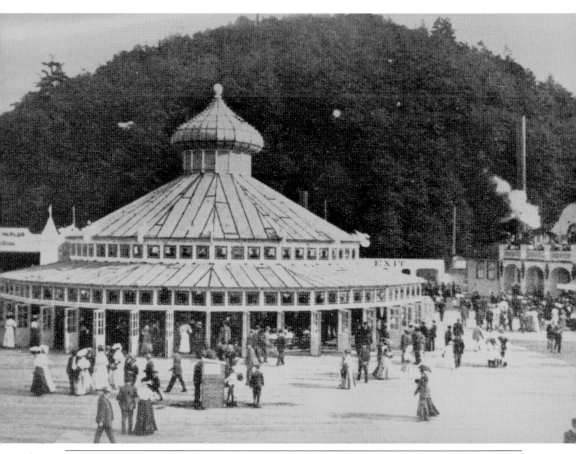

Upon its 1907 opening, Luna Park was billed as "Seattle's Coney Island of the West." The seaside amusement park was built on a pier at West Seattle's Duwamish Head. Before long, moralists protested open drinking and intergenerational dancing at the park. It closed in 1913. This carousel was dismantled and moved to San Francisco. A small monument now stands just onshore from where the park's pier had stood. (SMA no. 28786.)

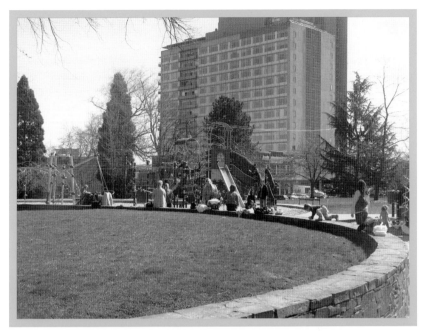

On this page and the next are slightly more respectable waterside entertainments offered along Lake Washington's shores. The Madison Street Park Pavilion was part of Judge John McGilvra's private lakeshore park that promoted his nearby land sales. The auditorium seated 500 for recitals and club meetings. It operated from 1890 until it burned in 1914. A children's play area now stands on what is now a city park. (SMA no. 29785.)

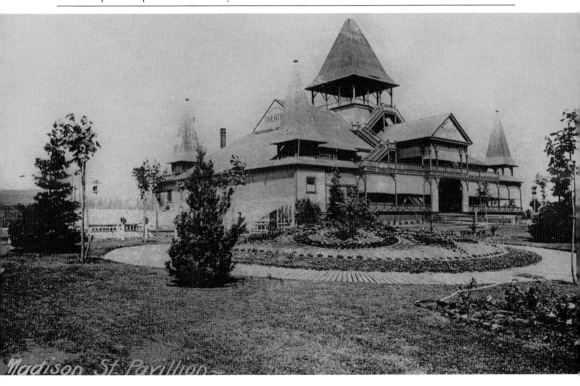

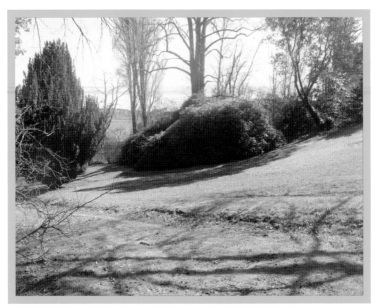

Situated a little over a mile down the lake from Madison, Leschi Park was another private amusement park at the end of a trolley line. Its attractions included this vast gambling casino and beer hall, as well as a private zoo. After the city took over the site in 1909, the casino was replaced by an open-air dance hall, now demolished. The park's namesake is a local tribal chief who once had a campsite on the current park property. He was hanged in 1856 for promoting violence against white settlers following a treaty that took away native lands. (SMA no. 29631.)

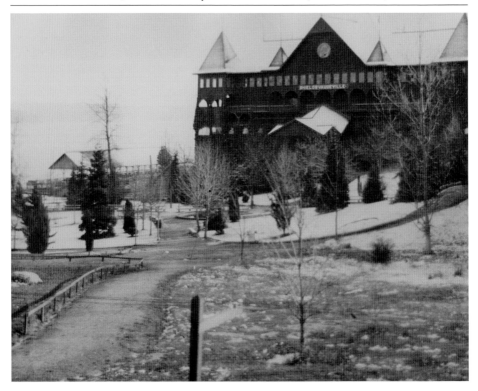

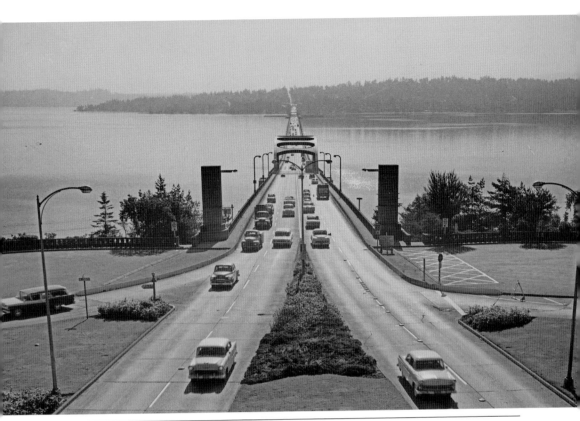

The Lacey V. Murrow Floating Bridge first crossed Lake Washington in 1940. It was named for a state transportation planner and brother of newscaster Edward R. Murrow. It's shown here in 1960, as the Eastside suburbs the bridge reached had just begun their explosive growth. Seen in the present-day shot, the new bridge to the left opened in 1989. The even newer bridge to the right replaced the original, which sank in a 1990 windstorm (it was closed for upgrades at the time). (SMA no. 63709.)

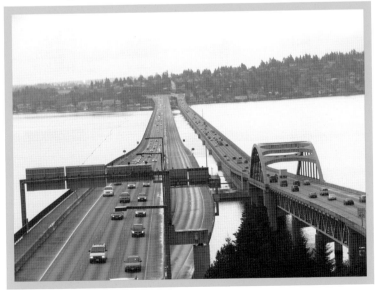

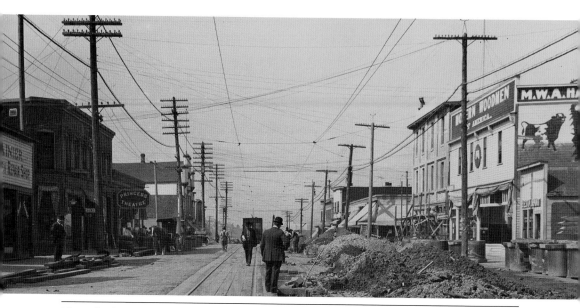

The Columbia City neighborhood in the Rainier Valley, inland from Lake Washington, was an independent city until residents voted to merge into Seattle in 1907. This 1913 image shows roadwork along Rainier Avenue South, the neighborhood's (and the valley's) chief retail strip. Postwar decades of neglect and racist redlining practices (it was one of the few parts of town where African Americans could buy homes) left its storefronts and housing stock available for more recent rediscovery and restoration. (SMA no. 6280.)

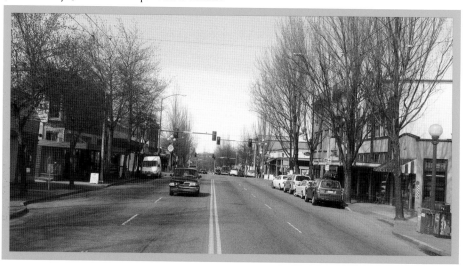

THE NEIGHBORHOODS

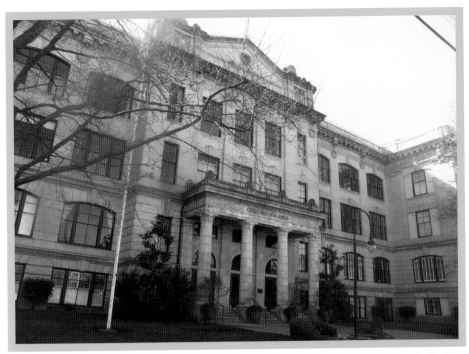

The neoclassical Queen Anne High School, opened in 1909, was planned from the ground up to incorporate progressive school-design ideas, including what school board member Edgar Blair described as "spacious corridors, ample exits, abundant light and fresh air . . . and toilet facilities on every floor." The school closed in 1981. The building, a federal historic landmark, was turned into apartments, and then into condominiums. (SMA no. 24387.)

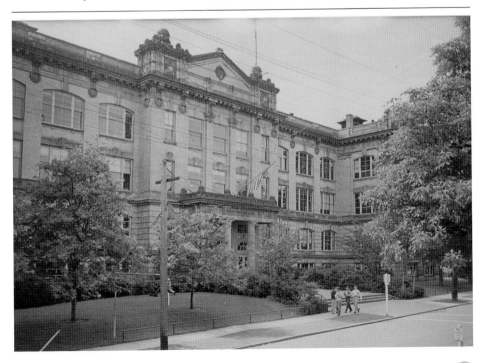

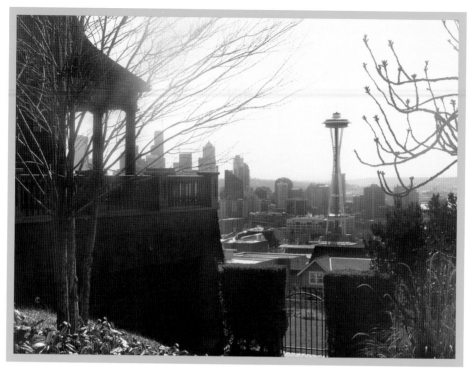

Downtown and Denny Hill are seen from Queen Anne Hill's Tower Place in this 1903 photograph by Olmsted Associates, the master planners of Seattle's park system. They were surveying potential sites for a view park. Buildings and trees now obstruct this specific view. The now photograph on this page was taken a block west and a block north of the earlier image. Queen Anne eventually got a public-viewpoint site in 1927 at Kerry Park, several blocks farther west. (SMA no. 30028.)

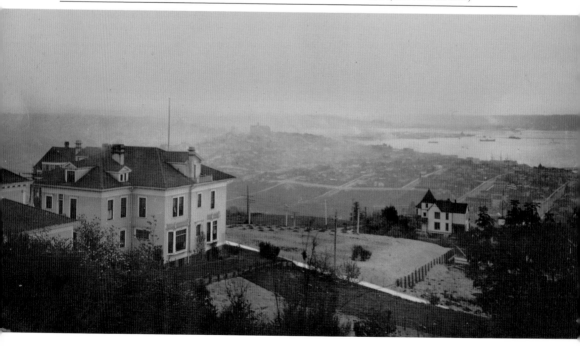

THE NEIGHBORHOODS

CHAPTER 5

ATTRACTIONS
AND LANDMARKS

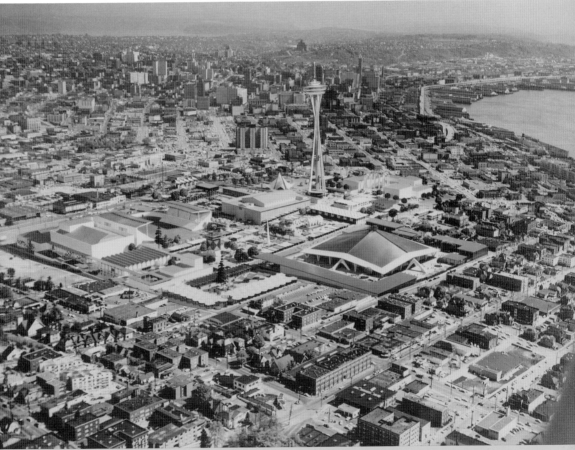

Promoters of the 1962 Century 21 Exposition created this c. 1961 airbrushed photograph to show how the world's fair grounds would look from the skies above Queen Anne Hill. Existing buildings on the site (Arena, Civic Auditorium/Opera House, Armory/Food Circus, and Memorial Stadium) are seen with representations of the fair's new buildings (including the Coliseum, Pacific Science Center, Playhouse, and Space Needle). Thankfully, the real Needle did not droop to one side, the way this painted version does. (WSDA.)

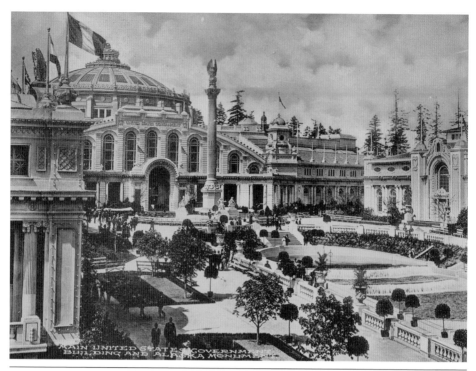

The 1909 Alaska-Yukon-Pacific Exposition was Seattle's first world's fair (though not officially designated as such). It kick-started local tourism and celebrated the city's arrival as a world trade crossroads. The AYP also helped fund development of the University of Washington campus, where the fair was held. Its chief temporary exhibition buildings were at the north side of Drumheller Fountain (also known as Frosh Pond), looking out toward Mount Rainier. (WSDA.)

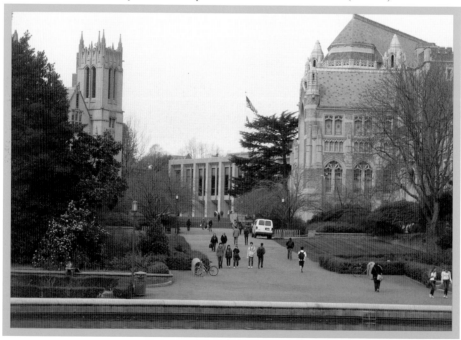

ATTRACTIONS AND LANDMARKS

Parrington Hall is one of the UW's oldest buildings. The pressed-brick edifice opened in 1902 as the Science Building. It was renamed in memory of English professor Vernon Parrington, who allegedly said the building was "the ugliest I have ever seen." The campus's oldest building, Denny Hall (1895), can be seen to the right in this 1930s postcard, but is obscured by trees in the modern image. (WSDA.)

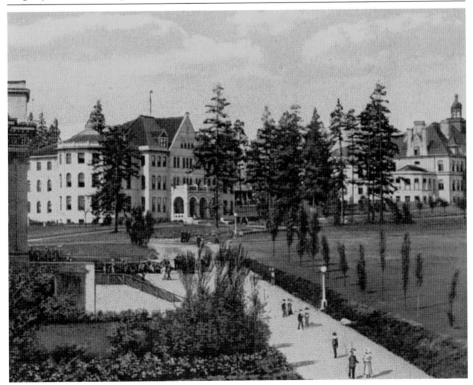

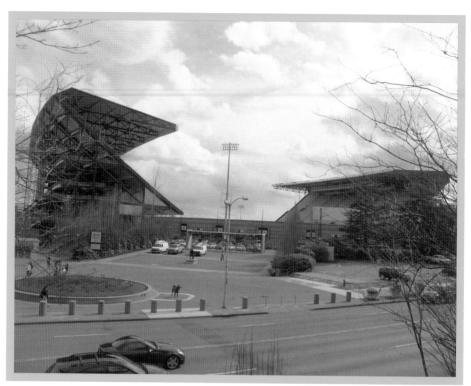

The UW's Husky Stadium is seen here during its original construction in 1920. Whether any season's football squad was triumphant or abysmal, the west end view toward Portage Bay was always spectacular. Tiered grandstands were added in 1960 and 1987. The stadium is now set to be made more thoroughly over; the field is to be lowered and the original seating bowl rebuilt. (SMA no. 12833.)

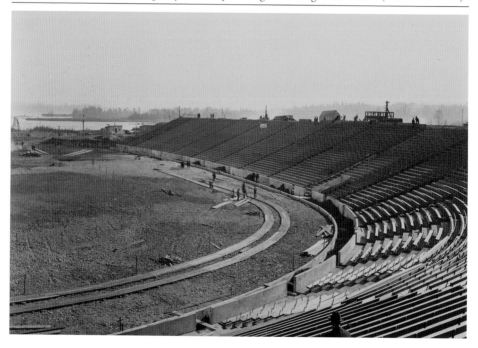

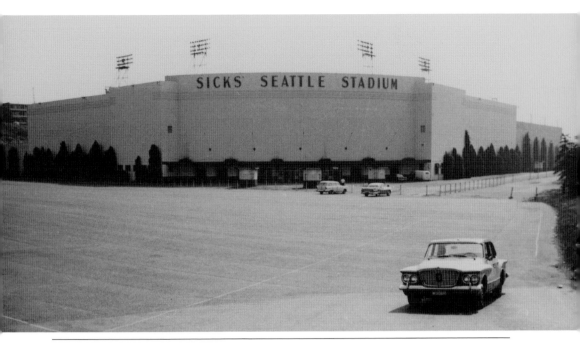

In 1938, Rainier Brewing owner Emil Sick bought Seattle's minor league baseball team. He renamed them the Rainiers and housed them in his new Sick's Stadium on Rainier Avenue South. In 1969, Sick's Stadium hosted the Seattle Pilots, the one-season major league team memorialized in pitcher Jim Bouton's memoir, *Ball Four*. There's a hardware superstore there now; a memorial sign can be seen in the lower left of the present-day picture. (SMA no. 77417.)

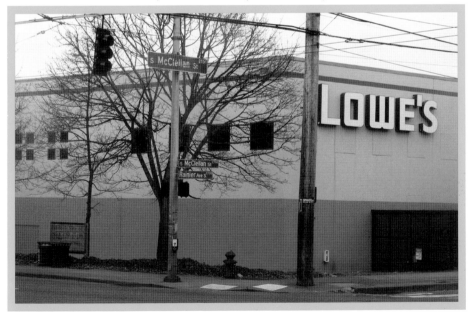

After the Pilots' departure, civic leaders sued to get back into Major League Baseball while getting a new stadium sited, designed, and efficiently built. The result was the Kingdome (King County Domed Stadium). Its exterior was a marvel of concrete engineering, albeit quite bland looking from ground level. Its interior was a loud party room for football, but a drab place for baseball. After a mere 26 years, it was imploded in 2000. The football-soccer Qwest Field stands in its place, with baseball's Safeco Field directly south of it. (King County Archive.)

THE KINGDOME
MAGAZINE

$2

SEATTLE, WASHINGTON MARCH 1976

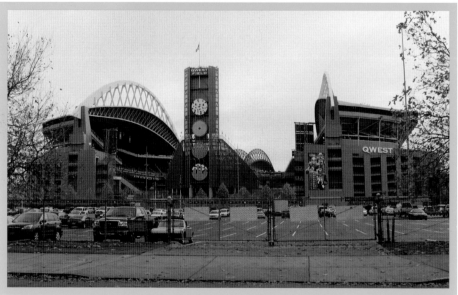

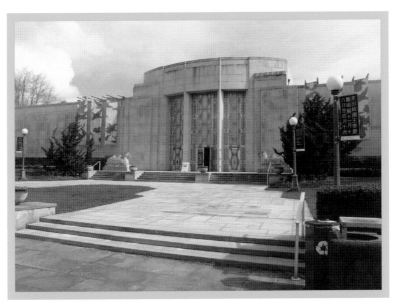

Volunteer Park at Capitol Hill's summit was one of several Seattle parks designed by New York's Omsted brothers in the 1900s. It was already a busy place when Richard E. Fuller organized the Seattle Art Museum (SAM) and persuaded the city to let it be built in the park. The understated, Art Moderne–style structure opened in 1933. In 1985, it was a major location in Alan Rudolph's film *Trouble in Mind*. When SAM's new downtown home opened in 1991, the Volunteer Park building became a branch facility, the Seattle Asian Art Museum. (SMA no. 61743.)

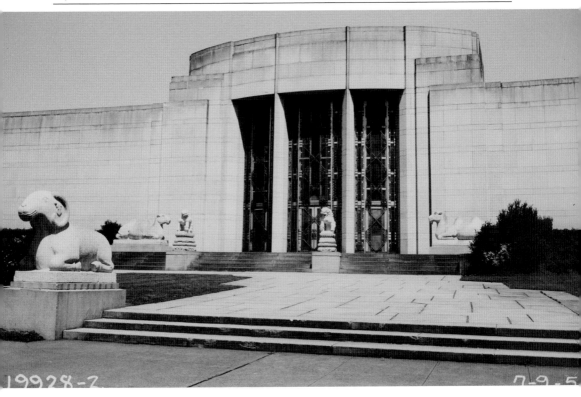

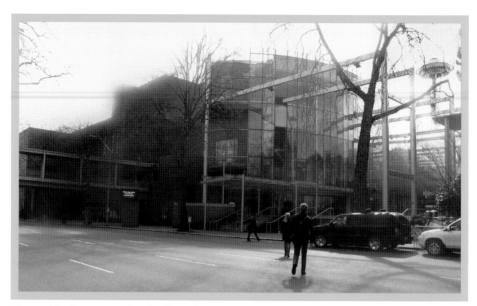

The world's fair was sited at the foot of Queen Anne Hill, partly because the area already had several adaptable buildings there. One was the Civic Auditorium, built in 1928 for major live concerts and community events. It was revamped for the fair into the Opera House. In 2003, it was remade again as McCaw Hall, but is still home to the Seattle Opera and art-film screenings. (VS or SMA no. 64017.)

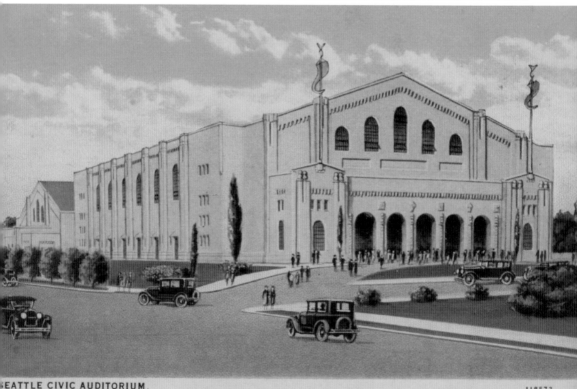

SEATTLE CIVIC AUDITORIUM. 118572

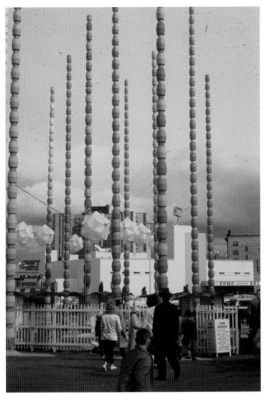

Eager tourists enter the world's fair grounds at its east gate near the Space Needle. The KOMO-TV and Radio building in the background first opened in 1946, seven years before telecasts were added to its output. KOMO's owner, Fisher Companies, later replaced it with the hi-tech and curvy Fisher Plaza, which opened in phases starting in 2000. It can be seen in establishing shots during *Gray's Anatomy*, a show carried locally on KOMO. (SMA no. 77809.)

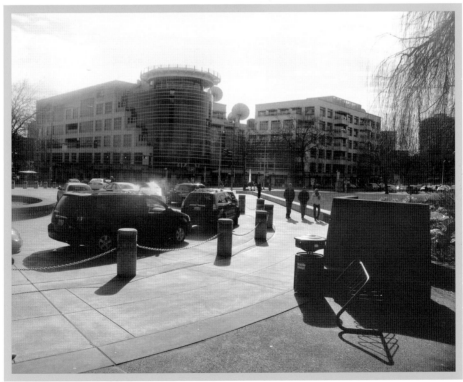

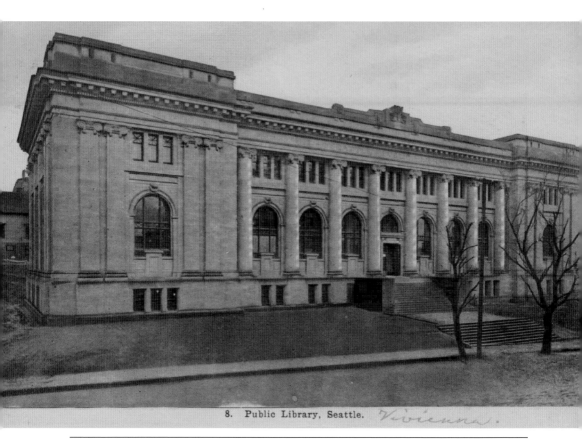

8. Public Library, Seattle. *Vivienne.*

In 1906, the Seattle Public Library first moved to Fourth Avenue and Madison Street in a 55,000-square-foot beaux arts stone edifice. That was replaced by a plainer, if more modern, building, open from 1960 to 2001. Today's world-renowned, 363,000-square-foot Central Library, designed by Dutch architect Rem Koolhaas, opened in 2004. (VS.)

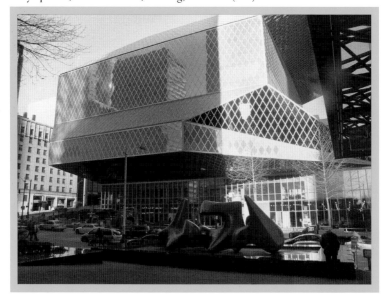

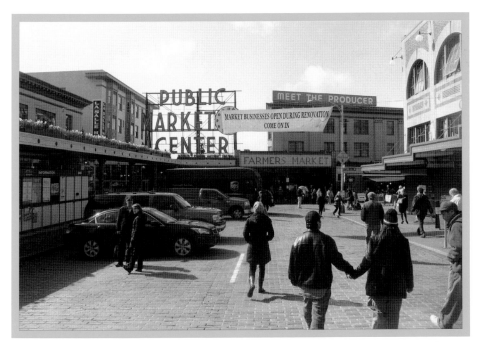

The Pike Place Market has seen times high and low since its 1907 debut. It began as a way for farmers to sell directly to customers, bypassing wholesale markups. In World War II, the Japanese American farmers who sold there were interned; the market began a quarter century of decline. When developers in the 1960s proposed razing the worn market buildings with office towers, preservationists fought back. They forced a 1971 initiative election, in which city residents voted to buy and restore the place. It is now being structurally renovated again. (VS.)

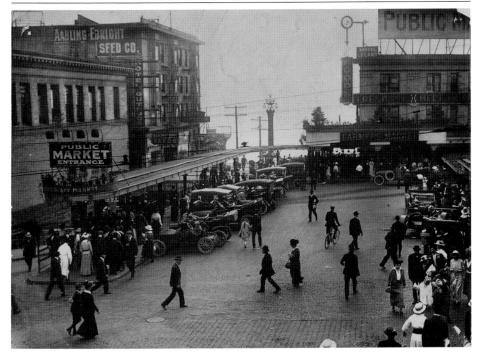

DISCOVER THOUSANDS OF LOCAL HISTORY BOOKS FEATURING MILLIONS OF VINTAGE IMAGES

Arcadia Publishing, the leading local history publisher in the United States, is committed to making history accessible and meaningful through publishing books that celebrate and preserve the heritage of America's people and places.

Find more books like this at
www.arcadiapublishing.com

Search for your hometown history, your old stomping grounds, and even your favorite sports team.